Published in 2013 by Stewart, Tabori & Chang
An imprint of ABRAMS

Library of Congress Cataloging-in-Publication Data
Azzarito, Amy.
Past & present / by Amy Azzarito.
pages cm
STC craft/A Melanie Falick book
Includes bibliographical references and index.
ISBN 978-1-61769-020-4 (alk. paper)
1. House furnishings. 2. Decoration and ornament—Themes, motives.
I. Title. II. Title: Past and present.
TX311.A99 2013
645—dc23
2012022910

Editor: Liana Allday
Designer: ALSO
Production Manager: Tina Cameron

The text of this book was composed in Gotham, FF Scala & Knockout
Printed and bound in China
10 9 8 7 6 5 4 3 2 1

THE ART OF BOOKS SINCE 1949

115 West 18th Street
New York, NY 10011
www.abramsbooks.com

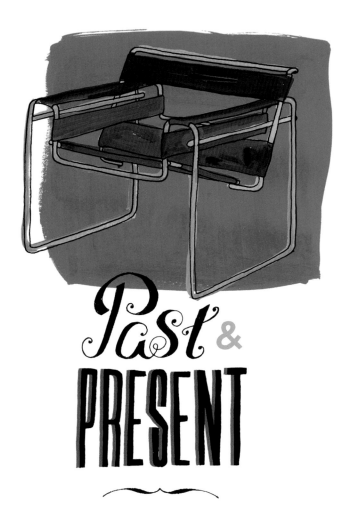

Past &
PRESENT

24 FAVORITE MOMENTS
IN DECORATIVE ARTS HISTORY
AND 24 MODERN DIY PROJECTS
INSPIRED BY THEM

BY Amy Azzarito

ILLUSTRATIONS BY Julia Rothman
PHOTOGRAPHS BY Ellen Silverman

STC Craft / A Melanie Falick Book / Stewart, Tabori & Chang
New York

TABLE OF CONTENTS

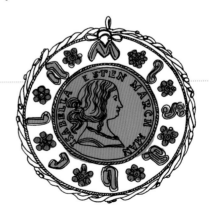

FOREWORD

OVER THE PAST EIGHT YEARS OF RUNNING DESIGN*SPONGE, I'VE SEEN COUNTLESS DIY, design, and decor books come across my desk. But I have never been as proud of or excited about a book as I am about the one you're reading right now.

I've been fortunate to work with Amy Azzarito since the fall of 2008 when we met while working on a video project for the New York Public Library. Amy, who worked at the library at the time, was producing the video series, and I acted as the host, following five local artists as they created work inspired by the library's collections. As I got to know Amy during filming, I was immediately struck by her intense passion for and devotion to learning.

A fellow art history major, I thought I had "design history" covered, but I was blown away to hear that Amy was putting herself through not one, but two graduate programs, in library science and the history of decorative arts and design, respectively. Her love of learning was infectious, and I found myself eagerly asking her questions about the provenance of classic furniture and design details, confident that she would not only know the answer, but would be able to cleverly explain the history by tying it to a contemporary concept.

She didn't know it at the time, but I immediately began planning a way to convince Amy to come work with me. I'd never met anyone so full of ideas, passion, and genuine excitement about sharing her knowledge with the people around her. Two years after our first meeting, Amy came to work with me full-time, and it has been a match made in design heaven.

Amy's unique way of tying the past to the present became the premise for the first regular column she wrote for Design*Sponge (which was aptly named "Past & Present"). Each month, she would check out countless library books to get the full story on a singular style, trend, or technique, distilling it down to the most essential details. She then paired the story with a DIY project that put a modern spin on the concept. The column was an instant hit and proved that Amy's unique style of teaching was successful not only with me, but with the tens of thousands of people reading the site every day.

After a lifetime of soaking up information and sharing it with others, it is particularly fitting that Amy has turned her passion into a book. Since she was a child, Amy has been devouring books, and at an age when most children were watching TV or playing video games, she was already deeply devoted to reading

everything she could find. In fact, I recently heard a story from Amy's mother, Sue Azzarito, about how she would often walk into the bathroom to discover Amy showering and reading a book at the same time, rotating which arm was in the shower and which was outside, holding the book and turning the pages. Amy was so dedicated to reading and learning that she couldn't stop long enough for even the most basic daily diversions (a character trait of Amy's that I still find to be true today). And now, Amy will see her own name on the cover of a book that, one day, her own children will be able to devour—or read in the shower before school.

Whether you're a lover of art and art history or just appreciate the DIY projects accompanying the essays, *Past & Present* is a book that will remain a trusted resource and source of inspiration for years and years to come. Amy has poured her love of art, design, and history into every page of this book, and I can't wait to see how it sparks the imagination and curiosity of readers of all ages.

GRACE BONNEY
Founder and editor in chief of Design*Sponge

INTRODUCTION

PUT SIMPLY, THIS BOOK IS A COMPILATION OF MY FAVORITE MOMENTS IN DECORA-
tive arts history. Rather than an academic or chronological overview of interior
design and architecture through the ages, I have focused on the things that I
find particularly interesting—the types of things that I might ramble on about
if we were at a party and I had had a couple glasses of wine. I might go on and
on about how Napoléon's wife, Empress Joséphine, was an amazing enter-
tainer and a gardening guru; and how
Napoléon caused a craze for obelisks
and other Egyptian relics with his
Egyptian military campaign in 1798;
or how, decades before Napoléon,
Louis XV had a private kitchen
installed in Versailles where he
learned the art of pastry-making from
the château's master chef. Little tidbits
like these are what connect history
to humanity, and they make me feel
closer to the story. But perhaps most
interesting of all is the discovery that
so much of the way we live our lives—
from the way we entertain to how
much privacy we enjoy to where we sit
when we watch TV—has a connection
to design.

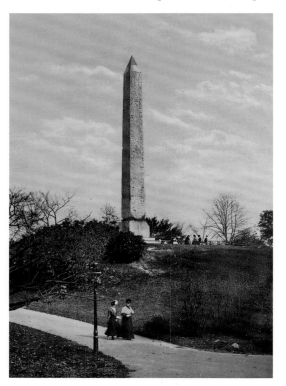

Since 1881, New Yorkers have
had to travel only as far as
Central Park to visit one of the
world's oldest monuments—
an ancient Egyptian obelisk.

My first memory of truly appreciat-
ing the nuances of decorative arts
history was when, at age eleven, I
discovered a book on my parents'
bookshelf called *Life in a Medieval
Castle.* To my surprise, it was not a story about princesses and court jesters, but
an actual account of life at court, describing the routines of a medieval lady, how
a man became a knight, and even how a royal house was organized. I can still
remember my astonishment at discovering that history could be so intricately
tied to the minutiae of daily living.

The Obelisk, Central Park, New York. The New York Public Library, Irma and Paul Milstein Division of United States History,
Local History and Genealogy.

Many years later, I continued my fascination with historical stories while I was getting a master's degree in the history of decorative arts at the Cooper-Hewitt Museum—an entire degree, in fact, devoted to studying the stuff in our houses. It was through this program that I began to realize the extent to which I could study the history of the world through daily objects. We were taught to look at an object and use it to tell a story: Who made it? What town or country were they from? What else was happening in the world at that time? And how did all of that affect how the object was designed, manufactured, and distributed? The answers to these questions were often surprising, and they typically made me want to dig even deeper into the topic. Lucky for me, I was working at the New York Public Library at the time, so I had all the research books I could ever want at my fingertips.

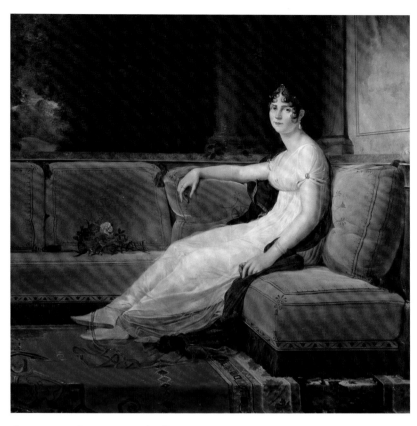

Empress Joséphine was Napoléon's first wife and a consummate entertainer. After a tour of the grounds to see her menagerie of unusual animals— black swans, gazelles, and kangaroos—the lucky guest would sit down to a table decorated with exotic flowers and fine porcelain, and eat the best food and wine available.

In 2009, just after graduating from Cooper-Hewitt, I had an amazing opportunity to join the online design magazine Design*Sponge. I wanted to find a way to get others as excited about design history as I was, and Design*Sponge founder Grace Bonney suggested that I write a column connecting a history lesson to the present. Thus my Past & Present column was born. I threw myself into writing essays on all sorts of things, from découpage to English kitchen gardens to French chandeliers. And since I was still working at the library, I had the privilege of being able to wander down to the stacks to peruse books for inspiration. Through this research I found fabulous old illustrations and unearthed forgotten stories and techniques that I was eager to share with the online world. In each post, I liked to give readers a DIY project based on the historical example, but benefitting the modern home. For instance, I rewired a

Joséphine de Beauharnais, 1763–1814 Empress of France, consort of Napoléon Bonaparte, at Malmaison, France, 1800. Musée national du château de Malmaison.

—— II ——

vintage hanging lamp to serve as my "antique French chandelier," and I faux-aged terra-cotta pots to bring a little English kitchen garden into my Brooklyn apartment.

For this book, I decided to take my Past & Present column to the next level, creating a collection of essays and projects covering twenty-four of my all-time favorite designers, objects, and moments in decorative arts history. Since it's always fascinating to see the way that styles progress over time, I have tried to present the historical information in chronological order. Admittedly, a large chunk of the book takes place in the 18th century, which was an unprecedented era in design history. From rococo style in France to Gustavian style in Sweden and Federal style in America, decorative arts were taking off globally during the 1700s, and objects that are so familiar to us now—such as sofas, cotton fabric, and private bathrooms with flushing toilets—had just been invented and were quickly gaining popularity. You'll also notice that some people, objects, or events come up over and over again throughout the essays, though they are usually presented from different points of view. For instance, the Great Exhibition held at the Crystal Palace in Victorian England showcased the design possibilities of the industrial era (see page 78); while the exhibition may have been a thing of wonder for most of England, young William Morris abhorred the mass-produced goods on display, and from that moment on, turned his talents to traditional folk designs (see page 90).

For those of us used to the stresses of modern airlines, the luxury and opulence of ocean liners in the 1920s and '30s wouldn't even be classified as travel. They were floating palaces. The *Normandie*, the crown jewel of the French Line's fleet, had a three-deck-high first-class dining room that was longer than the Hall of Mirrors at Versailles and could accommodate 700 diners.

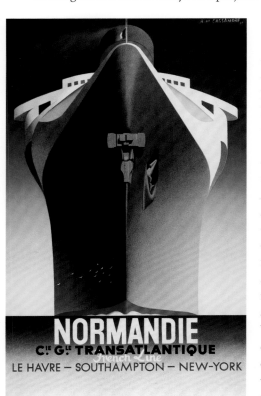

Mouron, Cassandre. *Normandie*, 1935. Lithograph. 39 x 24^{1}/$_{2}$" (99 x 62 cm). Printed by Alliance Graphique, Paris.
© Mouron. Cassandre. Lic 2012-17-08-01 www.cassandre-france.com

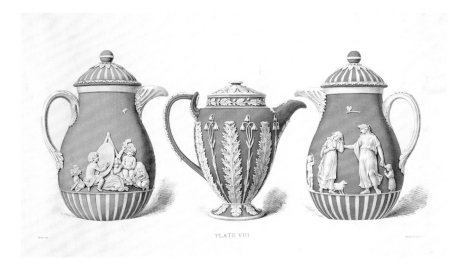

PLATE VIII

These beautiful designs are the work of Josiah Wedgwood. The story of Wedgwood is of the rags-to-riches variety. He grew up in a poor family of potters, but by the time he died, his pottery business had made him worth £600,000 (around $100 million today).

After creating a master list of my favorite decorative arts topics, I approached some of the artists and designers whom I admire most today to create a DIY project corresponding to a particular moment in design history. Sometimes the artists requested a favorite era—for example, Eddie Ross has always been a fan of Wedgwood, so he knew right away that he wanted to create a project reminis-cent of Wedgwood's Jasperware (see page 60). In other cases, I sent the artists my favorite photos from a given period and we brainstormed together. I'll never forget showing up at the CONFETTISYSTEM studio in New York's Fashion District, my arms piled high with books, and then flipping through photos of steamships and talking about luxury travel in the 1920s while surrounded by their festive garlands and sparkling metallic fringe. The resulting mobile/piñata project they created (see page 110) encapsulates all the joy and glitter of the Roaring Twen-ties and would have fit perfectly aboard a luxury liner of that era. Working one on one with each of these talented creators was one of the most satisfying parts of the writing process, and it was incredibly fun to see each person become enamored with the legacy of design history and eager to put his or her own spin on a style.

It is my hope that, like the designers who contributed to this book, you will be not only inspired by the stories, but also inspired to interpret historic moments in design history in unique ways. I encourage you to peruse this book in what-ever way makes sense to you: Read it from cover to cover, in a linear fashion, flip around to a particular moment in time that resonates with you, or look for the project by your favorite designer and re-create it with your own hands. Or, maybe after reading a particular essay, you'll want to get out your sketchbook and design a project of your own. After all, it is my intention in writing this book that, by appreciating the past, we can create an inspired present.

Three déjeuner pieces, 1898. The New York Public Library. Stephen A. Schwarzman Building / Art and Architecture Collection, Miriam and Ira D. Wallach Division of Art, Prints and Photographs. *Old Wedgwood, the decorative or artistic ceramic work*. By Frederick Rathbone. London, B. Quaritch, 1898.

Essays & PROJECTS

24 FAVORITE MOMENTS
IN DECORATIVE ARTS HISTORY
AND 24 MODERN DIY PROJECTS
INSPIRED BY THEM

A BRIEF HISTORY OF OBELISKS

IN 1881, BEFORE NEW YORK CITY HAD ELECTRICITY, BEFORE THE BROOKLYN BRIDGE was finished, and before the word "skyscraper" was even part of the English lexicon, one of the oldest skyscrapers in the world was erected in Central Park. Thirty-five hundred years after it was originally constructed in Ancient Egypt, it traveled 6,000 miles to Manhattan, where it stands to this day.

In ancient Egypt, the obelisk was considered a sacred homage to the greatest Egyptian deity, the sun god, Ra. These monolithic structures weighed hundreds of tons and stood as tall as 100 feet (30 m), with a tapered rectangular shaft topped by a pyramid. They were erected in pairs outside temples as a testament to the might of the Egyptian gods and pharaohs. Obelisks were carved out of the ground with small balls of a hard rock called dolerite, which workers used to pound away at the pink granite, pulverizing it and slowly creating a trench around the would-be obelisk. Once the trench was completed, workers tunneled underneath to free the shaft from the rock. It was a painstaking and treacherous process. After carving, the obelisks were hauled to the banks of the Nile, where the spring floods made it possible to transport them to the intended temple site. Once at the site, the obelisks were raised vertically, most likely under the watchful eye of the pharaoh. The obelisks were partially decorated at the quarry, but subsequent pharaohs would have their own inscriptions added over time—until the obelisks became completely covered in hieroglyphs.

The Romans were the first culture to become infatuated with Egyptian relics. After they subsumed Egypt into their empire in 30 BC, they became obsessed with all things Egyptian and had a particular affinity for the obelisk. Like any new homeowner, the Romans began to move things around to suit their needs, and even went so far as to transport ancient obelisks down the Nile and across the Mediterranean Sea, so they could sprinkle them throughout the Roman Empire. In fact, the Romans moved so many obelisks out of ancient Egypt that today there are more obelisks standing in Rome than in Egypt.

In the 18th century, a similarly powerful interest in Egyptian relics was sparked by Napoléon's military campaign in Egypt. In addition to his military troops, Napoléon brought with him an unprecedented 167 scholars and intellectuals. The antiquities they collected and brought back to Europe resulted in a flurry of publications that set off an Egyptomania craze. In addition to ancient Egyptian artifacts being placed in European museums and private collections, two obelisks were brought to the streets of Paris in the 1830s and one was brought to London in 1878. If New York wanted to position itself as a world-class city on par with the great capitals of Europe, it needed to have an ancient Egyptian obelisk, too.

That New York City came to possess one of the oldest relics in the world seemed only fitting to New Yorkers. After all, it was 1879—the Gilded Age—a time of overwhelming economic growth, prosperity, and possibility in New York

Once the obelisk arrived in New York, it took workers four months to transport it from the dock at 96th Street to its final destination in Central Park.

City. (This was the New York of John D. Rockefeller, J. P. Morgan, and Andrew Carnegie.) William Henry Hurlbert, editor of the *New York World*, spearheaded the idea of obtaining an obelisk by enlisting the support of several key politicians. This resulted in the American consul-general in Egypt, Elbert Farman, spending more than a year gently pressuring the Egyptian government to give New York City an obelisk. He finally succeeded, and plans got underway. William Vanderbilt supported the project to the tune of $102,576, and Commander Gorringe, veteran of the American Civil War, engineered the passage by which the 69-foot (21 m), 220-ton (199,580 kg) obelisk would move from Egypt to New York.

This wasn't, however, the obelisk's first journey. The obelisk destined for New York City was one of a pair carved from Egyptian quarries to mark Thutmosis III's third jubilee, which was a special anniversary of his reign (1479 BC to 1425 BC). In 12 BC, Caesar Augustus had moved the pair of obelisks from their original temple site to Alexandria. The obelisks, nicknamed Cleopatra's Needles, remained together until 1877, when the British transported one of them to London—a move that proved disastrous. In a shipwreck that killed six people, the obelisk became lost off the coast of Spain and had to be rescued and towed to London, where it was finally erected in 1878.

The overseas voyage of the second obelisk took just over a month and was much less eventful—it was the land journey that proved to be tricky. When it reached Staten Island, the obelisk was transferred from the ship to a barge, which then sailed up the Hudson River. It would take nearly four months to move the obelisk from the unloading point on 96th Street to the site in Central Park. It was so heavy, the engineers had to constantly devise new ways to move it. Ultimately, the obelisk was inched along a track; gangs of men were hired to remove the track beams from behind the obelisk, grade the ground in front of the caravan, sink the anchors for the stationary block, and reposition the track beams, all on a route that was carefully planned in order to minimize the number of turns the obelisk would need to take. It was the greatest show in town, and New York became gripped by obelisk fever. Crowds stood by, gawking at the massive rock, and street vendors set up moving stands that traveled alongside. Many observers came with hammers and chisels, until these souvenir seekers became so out of control that a twenty-four-hour guard had to be hired. Finally, on January 22, 1881—a full fifteen months after the voyage had begun in Alexandria—a crowd of 5,000 people gathered in the snow to watch the erection of the obelisk in the park, where it still stands. Great care was given to ensure that its orientation to the sun was exactly the same as it had been in Alexandria.

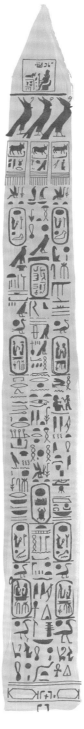

The hieroglyphics shown here adorn one of the four faces of the obelisk that stands in New York's Central Park.

OBELISK CLOCK

designed by TIMOTHY LILES

Our culture's captivation with ancient Egypt continues to this day, and obelisks still pop up frequently in modern decor (usually in the form of bookends or mantel decorations). Obelisks also appear in more unexpected ways, like on the clocks shown here. Designer Timothy Liles used pointed obelisk-shaped Post-it flags in neon colors to create a decorative element across clock faces. The clock itself, which marks the movement of the sun, is a little nod to the obelisk's original purpose: to honor the sun god, Ra.

INSTRUCTIONS

1 There are usually three or four tabs holding a clock's cover in place; pry them back with the head of the screwdriver until the cover comes free. It's not necessary to remove the hands or ticking mechanism; as you attach the flags, you can simply move the clock hands out of your way as needed.

2 Your design will be based on a straight line. To create this line, lay down a strip of painter's tape anywhere on the clock's face. This will establish a consistent first row of stickers on which you will build the rest of the pattern.

3 Attach a lengthwise row of stickers along the edge of the tape, making sure to keep the spacing as even as possible. (Because you eyeball the spacing, it won't be perfect, but the naked eye will not pick up discrepancies in the finished piece.) When you get to the end of the row, the last sticker may go beyond the edge of the clock face. Trim it carefully with the X-Acto knife so that it perfectly meets at the edge of the clock's face or the plastic rim.

4 When the first row is complete, remove the painter's tape. For the next row of stickers, reverse the direction in which the arrows point. Keep 1/8 to 1/4" (3 to 6 mm) of spacing between the rows. Keep laying down successive rows of stickers, alternating color, direction, and even varying spacing if it looks good to you. When thinking about your design, make sure to consider which parts of the numbered clock face you want to show, and how much you want to cover up.

5 When you finish placing the stickers, set all the hands of the clock back to 12; this will ensure that when the clock starts ticking again, everything will move at the proper rate. Snap the plastic cover back into place, and you're done!

MATERIALS

Clock with a plastic face and a removable plastic cover (see Resources, page 142)

Post-it Arrow Flags, 1/2" (12 mm) size (available online or at any office supply store)

TOOLS

Flathead screwdriver

Painter's tape

X-Acto knife

During the Renaissance, a studiolo was a place to display treasures as well as to demonstrate one's knowledge and sophistication.

THE RENAISSANCE, WHICH SPANNED roughly the 14th to the 17th centuries, was a time of passionate curiosity. Johannes Gutenberg invented the first movable-type printing press, which led to a rapid exchange of ideas between great thinkers of the time. There was a new-found reliance on scientific discovery in every subject from astronomy to anatomy, and there was also the discovery of a new continent. For many during this time, there was a strong desire to collect objects of fascination. Many things that we consider common today—such as forks, mechanical clocks, compasses, and microscopes—were newly invented marvels, and to possess them said much about one's stature and intellect. One of the unlikely leaders in the movement toward collecting items of interest was Isabella d'Este, who, during her lifetime, became the most successful female collector in a man's world.

Coming out of the bleak medieval period, the Renaissance was a time of unprecedented luxury throughout Europe, and nothing was built with as much extravagance as the homes of wealthy Italians. In 1474, Isabella d'Este was born into just such a home, the eldest daughter of the ruling family in Ferrara, Italy. At a time when most women were illiterate, Isabella's more progressive father insisted that she learn Latin at the age of five. She was also given instruction in music and had a dancing master who taught her how to move, sit, and behave. The all-important goal was to make her a desirable bride, and by age six, precocious Isabella was already betrothed. She spent her childhood perfecting her Latin and learning Greek, and when she was sixteen, Isabella left Ferrara to marry Francesco Gonzaga and become the marchesa of Mantua.

Like most new brides eager to begin nesting, Isabella aspired to make the castle in Mantua something of a home. She hired a Neapolitan chef (chefs from Naples were considered the best), purchased a fluffy white lap dog and a Persian kitten, ordered new linens, bed covers, and wall hangings, and procured Murano crystal glasses and a Faenza dining service. She was drawn to the newest and most fashionable goods and implemented many comforts of the home that are standard today. (At a time when it was standard for guests to bring their

own cutlery when invited to dinner, Isabella was among the first to provide individual place settings with matching chairs, as well as cutlery, glasses, and a plate for each diner.) All of the objects that filled her home became crucial components in creating an atmosphere of elegance and extravagance. This type of beauty was so novel that a new word was coined to describe it: *splendor*.

In Mantua, Isabella sought to create splendor in her own wing of the castle, where she would live for the next thirty years surrounded by a coterie of female attendants and a troupe of dwarfs to entertain her. From one of her private apartments, Isabella added a small staircase that led to a studiolo. The purpose of a studiolo was for studying, but it was also used to show off private treasures to guests (studiolos are considered the precursor to modern museums). It was highly unusual for a woman to have a studiolo, but Isabella was a highly unusual woman. She not only possessed an extraordinary intellect, but also exhibited the same voracity for collecting as a typical wealthy Renaissance man.

Many of the items featured in a studiolo were one of a kind. Isabella was particularly captivated by works of art, and commissioned pieces from leading artists of the day. She was also known to aggressively seek antiquities that had been excavated in Rome, oftentimes writing countless letters and begging friends for favors until she got what she wanted. Her collection grew to include hundreds of books, instruments, statues, and paintings, and she would stop at nothing to obtain a piece that intrigued her.

Not only were the objects within the studiolo important, but the space itself was intended to be an intellectual curiosity. Up until this time, wood paneling had only been used decoratively in churches and castles, but artisans in the Renaissance took wood decoration to an entirely new level with a technique called intarsia, where small pieces of wood and tile were fitted together to create intricate pictorial images. The most talented craftsmen were able to make each pictorial inlay look three-dimensional, using a type of linear perspective that had just been discovered. Isabella's studiolo employed all of these tricks, with elaborate inlay on the walls, colorful inlaid tiles on the floors, and symbolic pictorial representations incorporated throughout.

As her prized collection grew, she added a room beneath the studiolo —a blue and gold cavelike grotto with a gilded, vaulted stucco ceiling. It was the ideal space for showing off a collection that she spent a lifetime accumulating. After Isabella's death in 1539, the collection remained intact for nearly one hundred years until Charles I of England purchased much of it; the rest was scattered throughout Europe. Then in 1797, when Napoléon's army invaded Mantua, they ransacked the city, taking everything that remained, and even destroyed Isabella's grave. Remarkably, the two rooms that housed Isabella's private collections still stand in the Ducal Palace in Mantua, Italy, and were restored in 2008–2009.

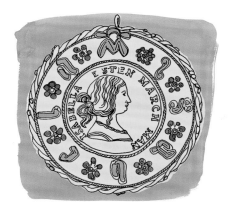

In 1498, Isabella d'Este commissioned a cast-bronze medal of her likeness in profile, modeled after the coins from ancient Rome in her collection. Her personal copy of the medal was set with diamonds and enamel flowers, but she also presented copies of the medal to favorite poets and nobles visiting her palace.

FURTHERMORE

Isabella d'Este's husband had a lengthy affair with Isabella's sister-in-law, the infamous and beautiful Lucrezia Borgia, who was the illegitimate daughter of the pope.

•

During the Sack of Rome, in 1527, Isabella converted her house into an asylum for roughly 2,000 people fleeing the Imperial soldiers.

INLAID EASEL

designed by JONATHAN ANZALONE AND JOSEPH FERRISO

For this practical, modern creation, Jonathan Anzalone and Joseph Ferriso of Anzfer Farm were inspired by the intarsia woodworking techniques of Renaissance craftsmen. To get the look of inlaid wood without all the tricky cutting and fitting, they created a faux-inlay using chipboard. When the pieces are locked in place, it makes a stand that is perfect for holding your smartphone or e-reader while you cook or read, or simply while it charges.

INSTRUCTIONS

1 Using the pencil and ruler, section the chipboard into four identical 5 x 7" (10.5 x 14.8 cm) pieces. Lay the chipboard on a cutting mat and cut along the marked lines using the ruler and mat knife.

2 Orienting the boards vertically, draw a horizontal line 2" (5 cm) from the bottom on all four boards. Draw another horizontal line 5/16" (8 mm) below the first line on all boards. Draw two vertical lines on each board, 2 1/2" (6.3 cm) from each side. You should now have four panels with identical traced lines. Divide the panels into pairs and keep them grouped together for the next step.

3 You'll now create a "half-lap," which will allow the panels to interlock. Using a ruler and mat knife, score and cut out a 5/16" (8 mm) wide slot on each panel: On one pair cut out the left side section only; on the other pair cut out the right section only.

4 Pick a board from each pair to be the inlay design face. On these boards, draw a geometric design. We cut out triangle shapes, but you can use rectangles or circles or any shapes you like; just make sure that they will be easy to cut out and paint. Put aside your other two boards; they will become the backing boards.

5 Using the ruler and mat knife, cut out your geometric design from the board. You should now have puzzlelike pieces, which you will paint and piece back together. Using acrylic paint, brush a thin coat over one side of all the puzzle pieces, adding a second coat if needed. Use a different color for each shape.

6 Once the paint has dried on the inlay pieces, reassemble them and attach the pieces to the backing board with multipurpose glue. Be sure to align the cutouts so that the edges meet neatly and the passage for the half-lap is clear. Put a heavy book over the boards while the glue dries.

7 Touch up the paint on the front of the board, if needed; once the front is dry, paint the edges and the backside of the boards in a solid color.

8 When all the paint has dried, slide the two cutouts into each other so that the easel stands up.

MATERIALS

4 sheets of 8 1/2 x 11" (A4) chipboard, 1/8" (3mm) thick

Acrylic paint in several colors

Multipurpose glue

TOOLS

Pencil

Ruler

Mat knife

Cutting mat

Paintbrush

Heavy book

VIRTUALLY EVERY TOWN IN AMERICA HAS A BANK OR COURTHOUSE THAT PAYS homage to the Renaissance architect Andrea Palladio. From large classical columns surrounding a porch or covered entryway, to dramatic arched windows on a second story, to domes and classical symmetry—all of these familiar features were made popular by Palladio, and more than 500 years later, they still evoke a feeling of grandeur. Many of these architectural features were borrowed from Roman temples and palaces, but Palladio was the first to use them in a context that could be enjoyed by nonroyals—more specifically, for private villas in Venice. Palladio's influence was so great that he is one of the few architects to have a style named after him.

Andrea Palladio was born Andrea di Pietro dalla Gondola in the Venetian Republic in 1508, just sixteen years after Columbus discovered the New World. Born during the Renaissance, he worked in Venice at the same time Michelangelo was working in Rome and just before William Shakespeare started writing in England.

A Palladian window is divided into three parts: an arched central window and two narrower windows on either side. The form is thought to have been derived from triumphal arches, like those through which the Roman emperor Caesar marched his armies.

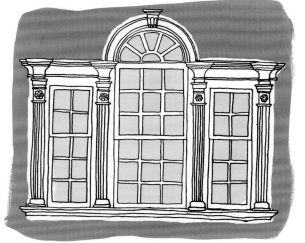

Palladio got his start as a stonemason, which made his transition to architecture particularly unusual. Not only was it impressive for a young man in his early thirties to make the leap from manual laborer to architect, but he also didn't have a background in the arts, which was the common career path for architects at that time. For instance, Michelangelo was already an established painter and sculptor before he began designing buildings at age forty-six, and Filippo Brunelleschi was a goldsmith and clockmaker before designing his great dome in Florence. Similarly, Renaissance architects Giorgio Vasari (who built a passage in Florence that connects the Uffizi with Palazzo Pitti) and Donato Bramante (who designed St. Peter's Basilica) both started out as painters. Palladio, however, had only his skills as a stonemason, his intense intellectual curiosity, and his youthful energy. As a young stonemason, Palladio carefully studied the work of Vitruvius, an ancient Roman architect whose architectural treatise had only just been rediscovered. Vitruvius's theories on classical Roman architecture greatly inspired Renaissance architects, especially Palladio.

Palladio's big break came when his stonemasonry workshop received a commission to modernize part of a home for Count Giangiorgio Trissino, a leading Renaissance humanist and a member of one of the oldest families in Venice.

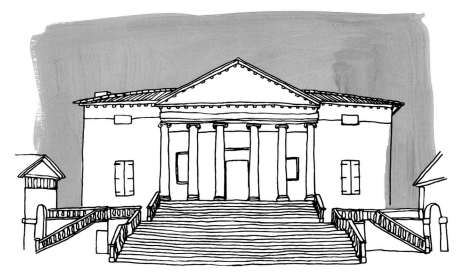

Designed in 1556, the Villa Badoer in Venice is a classic Palladian villa, featuring a portico, monumental-style staircase, and pediment supported by six Ionic columns. The portico went on to become the most imitated of all Palladian elements, even gracing the White House in Washington, D.C.

The exact circumstances surrounding the meeting of Count Trissino and Palladio and what exactly sparked the count's interest in the young man remains a mystery. But somehow, he recognized Palladio's talent and took him under his wing. Count Trissino had substantial influence in Venice, and his friendship allowed Palladio to move in completely different circles. The count gave Andrea a new last name—Palladio, which was the name of an angelic messenger in an epic poem the count was writing—and even more important, he took Palladio to Rome. In Rome, Palladio was exposed to classical architecture, and the trip had a substantial impact on his subsequent work. Palladio approached the ancient buildings with a measuring tape, a plumb line, and a compass with a sighting device, taking full advantage of the opportunity to study Roman architecture at its epicenter.

Palladio went on to design several churches in the Venetian Republic, but the real opportunity to experiment came when he began designing villas for wealthy Venetian citizens. Even in his early, relatively modest villas, Palladio began to play with Roman design elements on their facades, frequently mimicking a classical temple front—a device that became his signature.

Palladio later cemented his reputation with a treatise that illustrated the principles of classical Roman architecture. Palladio's *The Four Books on Architecture*—which is still in print—significantly influenced 18th-century English country house architecture. Those ideas then migrated from England to the newly founded United States, where the architectural ideas of ancient Rome seemed particularly fitting for the new republic (see page 66).

The legacy of Palladio can still be seen in some of the most important buildings in America: the U.S. Supreme Court's portico, the flat dome on the National Gallery of Art, the massive columns on the New York Stock Exchange building, and even the portico of the White House. All these classic designs pay tribute to the Renaissance architect that historians now call "the godfather of American civic architecture."

(see page 66).

FURTHERMORE

Being an architect in Renaissance Italy was not a lucrative career. Architects were paid only a minimal fee for their ink drawings (graphite had yet to be invented).

•

We can thank Palladio for high ceilings—he devoted an entire chapter to the subject in his treatise The Four Books on Architecture. *According to his calculations, an optimal room should be as tall as it is wide.*

PALLADIO TOTE BAG

designed by **BOOKHOU**

The design for this tote was inspired by the geometric symmetry found in ancient Roman, a key feature in Palladio's designs. For this project, Bookhou adapted the geometric look to a modern home tote, which can be used to hold everything from fireplace kindling to farmers' market produce.

INSTRUCTIONS

1. Iron the interfacing onto the reverse side of the black cotton muslin, leaving the paper backing on the interfacing.

2. Cut out sixteen 4" (10 cm) squares from the black muslin fabric with a ruler and rotary cutter. Cut each square in half, creating two 2 x 4" (5 x 10 cm) rectangles. Then cut each rectangle in half along the long diagonal, so that you have four identical right triangles. Repeat with all the remaining squares.

3. Photocopy the tote bag template (see page 118) at 200% and cut out the pattern piece. Lay your canvas and muslin lining fabric out on the fold, with the selvages on top of each other. Pin the pattern piece to the fabric so that the "fold" edge is perfectly aligned with the fold of the fabrics. After you cut out the first piece, move the pattern and cut out another piece, on the fold, from each fabric.

4. Align the 90-degree angle of the first triangle with the lower right-hand corner of one of the canvas bag pieces. Remove the paper backing from the interfacing, and, with the interfacing-side down, iron over the piece firmly with dry heat to fuse the interfacing to the canvas. You can also topstitch around each piece for a more secure bond.

5. Continue to add triangles, working in rows. Align the base of each triangle with that of the previous one and iron on each piece one at a time, until all the triangles are placed. Repeat with the other piece of canvas.

6. Sew the bottom and the sides of the two pieces of canvas together with the right sides facing, ignoring the cutout square in the lower corners of the bag. To make the gusset, pinch the cutout squares together, so that the bottom and side seams are matching, and stitch along the gusset opening.

7. Sew the muslin together as you did the canvas. Put the lining in the bag, right sides together. Pin the canvas and the lining pieces together at the top, making sure the right side of the canvas and the right side of the lining are facing each other. Sew around the upper edge of the bag and the sides of the straps, stopping your stitching about 1" (2.5 cm) from the top of the strap. This will leave the top of the strap open.

8. Turn the bag right-side out through the opening at the top of the strap. Stitch the top of the outer bag strap together, right sides together. Repeat with the lining strap (you'll have to do some maneuvering since you're working in a small space). With a hand-sewing needle and thread, stitch the openings on each side of the strap closed.

9. Using the iron, press the entire piece.

MATERIALS

1/4 yard (.25 m) of double-sided fusible interfacing (with paper backing)

1/4 yard (.25 m) of black cotton muslin

1/2 yard (.5 m) of natural-colored cotton canvas

1/2 yard (.5 m) of natural-colored cotton muslin for lining

Thread

TOOLS

Iron

Ruler

Rotary cutter

Straight pins

Scissors

Sewing machine

Hand-sewing needle

NOTE

A 1/2" (13 mm) seam allowance is included on the bag template.

17th-Century
VENETIAN MIRRORS

AT FOUR IN THE MORNING IN THE SPRING OF 1665, A SMALL GROUP OF VENETIAN glassmakers said good-bye to their families and joined a convoy that would take them to Lyon, France. It had taken two years and significant amounts of money for the French to lure these artisans onto French soil, but the cost seemed well worth it. For nearly 150 years, glassmakers in Venice had been jealously guarding the secrets of mirror-making, and the French were determined to claim that knowledge.

The earliest mirrors had been made in ancient Egypt. These small, polished bronze or copper discs were attached to handles, and the mirrors' round, reflective surfaces were thought to mimic the dazzling effect of the sun. The Romans were also obsessed with mirrors, and in addition to making them from metals, they used obsidian—a black volcanic rock that becomes reflective when highly polished. But mirrors as we know them didn't exist until the Venetians started making them in the 10th century.

To make such mirrors, one first had to create a piece of flat, thin, clear glass, and then apply reflective silvering. The thermal shock from the hot layer of silvering usually caused the thin glass to break—but in the 14th century, the Venetians figured out how to apply lead without heat. Eventually, in the 16th century, they started using mercury for the silvering. The Venetians also figured out how to make the glass clear (the trick was using ashes from the Egyptian herb kali, which acted as a bleaching agent). These advanced mirrors were quite small by today's standard—they would not have been larger than a tea saucer—but the quality was unlike any that had been seen before. Consequently, Venetian mirrors were imported all over Europe and even sent to Middle Eastern countries, such as Iran.

To protect the secrets of glassmaking, the workshops were moved to the island of Murano, just off the shores of Venice, in the 13th century. This move also protected Venice from the threat of workshop fires. Venetian glassmakers at this time were held in high esteem and were granted special privileges. For example, they were paid extremely high salaries, were exempt from taxes,

On the final evening of Marie Antoinette and the future Louis XVI's spectacular ten-day-long wedding celebration, King Louis XV dramatically launched a fireworks display by flinging a flaming spear from an open window in the Hall of Mirrors. The fireworks extravaganza erupted over the palace gardens and concluded with 20,000 rockets that looked like falling stars as they fell from the sky.

had the right to wear swords, and could marry into the nobility. The only catch was that they were not allowed to leave Venice—each glassmaker possessed the secrets of centuries of glassmaking artisans, so to leave the city was considered an act of treason.

In the 17th century, the French appetite for luxury knew no bounds, and one of the most luxurious items one could possess was a mirror. In fact, a Venetian mirror with a silver frame was worth nearly three times the cost of a painting by Raphael. With the entire country mirror-crazed, it was no wonder that the French government was so eager to have Venetian glassmakers teach the French how to make mirrors. After the artisans arrived, though, very few mirrors were actually produced. The glassmakers were extremely protective of their knowledge and petulantly refused to allow French glassmakers to work alongside them, even though they had agreed to come to the country for that express purpose. Accidents were frequent, and when one worker was out of commission, the rest refused to work. Tension increased when the immigrants formed two gangs—one group jealous of the skills of the other—and armed themselves with matchlock guns. The resulting violence shut down the factory for days.

All the while, the Venetian government, who wanted the glassmakers to come home, sent secret agents to France to offer safe passage and promises of leniency for their treason. (They also stooped to sending fake letters from the glassmakers' wives, insisting that they return.)

The French found the Venetians ill-tempered and defiant, so there was little resistance when the glassmakers left. They were, as promised, allowed to go back to work in Murano, but were mistreated by their glassmaking colleagues who were angry at them for leaving in the first place. The rebel glassmakers were so miserable that they requested permission to return to work in Paris, but to no avail. French politician Jean-Baptiste Colbert responded, "They gave us so much trouble when they worked in the factory and were so full of ill-will that I don't believe it advantageous to call on them a second time."

The French glassmakers continued to experiment with blowing flat sheets of glass, and finally, in 1670, they achieved an even greater success than the Venetians—a new casting technique that allowed for much larger panes. And so when Louis XIV decided to transform a hunting lodge at Versailles into a palace in 1678, the French-made mirrors played a key role in the decoration. In total, the designers used 306 mirrors in the aptly named Hall of Mirrors, which beautifully reflected the landscape just outside the windows. To complement the reflective qualities of the room, it was also filled with solid silver furniture and forty-one rock crystal chandeliers, creating the most magnificent space of its time. It was a message to the Venetians that they had lost their monopoly, and an advertisement to the rest of Europe that the French had taken over the luxury industry.

MIRROR MOSAIC PLANTER

designed by **GRACE BONNEY**

To create this mosaic planter, Design*Sponge founder Grace Bonney took inspiration from the way the Hall of Mirrors in Versailles reflects the estate's vast gardens. Any plant will look great in this mirrored container, but for a touch of Versailles, plant a dwarf lemon tree or a topiary, both of which were abundant in the palace gardens.

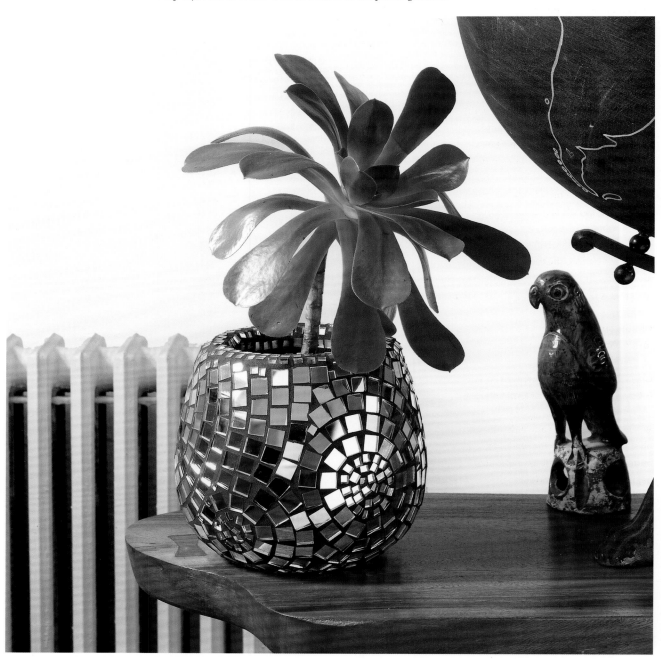

INSTRUCTIONS

1 Lay the scrap paper on a flat work surface. Use a glass or compass to trace a 2" (5 cm) circle near the center of the paper.

 Take the 1/4" (6 mm) tiles and line them up along the inside of the circle. Use more squares to create smaller and smaller concentric circles within the 2" (5 cm) circle— the innermost circle will likely be just three tiny squares. Then take the 1/2" (13 mm) tiles and line them up around the outside of the 2" (5 cm) circle, leaving as little space between the two circles as possible. Continue building outward with the tiles, creating three or four larger circles.

2 Start a new circle, either placing it right next to the previous one or overlapping it and creating a partial circle design. Use the same method of drawing the circle, then placing the smaller tiles inside and the larger tiles outside. Repeat these steps until the pattern fills an 8 x 18" (21 x 46 cm) rectangle. Some of your circles will be cut off at the top and bottom of the pot, but that's part of the design. Once you have the tiles all laid out, you can begin transferring them onto the pot.

3 Scoop 1/2 cup (120 ml) of thin-set mortar into a plastic tub. Add a few drops of water and stir, adding more water until the mortar is the consistency of yogurt. Begin spreading the mortar onto the pot with a plastic knife to about 1/8" (3 mm) thickness, working in small 2 to 3" (5 to 7.5 cm) sections. Transfer the design onto the pot one tile at a time and push the tiles into the mortar. If any tiles fall off during this process, simply add a dab of mortar to the backside of the tile and press it into place. If a lot of tiles are falling off, it means you are spreading your mortar too thin.

4 Use the smaller squares to wrap over the top edge of the pot and 2" (5 cm) down into the inside. Once all the tiles are in place, let the mortar dry for 24 hours.

5 Check the dry pot for loose tiles. If any fall off, use a strong gel adhesive, such as E-6000, to glue them back into place, and let the pot sit for another hour.

6 While wearing gloves and a dust mask, scoop a cupful or so of grout powder into a plastic tub, gradually add water, and stir until the mixture has the consistency of peanut butter. Let the grout sit for 5 minutes, then working on a protected surface or outdoors, begin scooping the grout onto the pot and pushing it into all the cracks. Cover the entire surface; when done, scrape off excess grout by rubbing the pot gently with a rag in a circular motion (swap in a fresh rag when the old rag becomes too dirty). Once most of the excess grout is removed, let the piece sit for 5 minutes so the grout can set. To check whether the grout is dry, rub a clean hand across the surface—the grout is set when it no longer smears onto the mirrors.

7 To finish the piece, gently rub the entire surface with a damp rag to clean and polish the mirrors. Let the piece dry completely, and it's ready for a plant.

MATERIALS
Two hundred 1/4" (6 mm)
mirror tiles and five hundred
1/2" (13 mm) mirror tiles (see
Resources, page 142)

Medium-size round ceramic
planter (about 7" / 18 cm tall
and 7" / 18 cm in diameter)

Thin-set mortar

Grout powder,
charcoal colored

E-6000 glue or other
strong adhesive

TOOLS
Piece of scrap paper 12 x 20"
(31 x 51 cm) or larger

Glass or compass

Pencil

Two 12-ounce (355 ml)
plastic tubs

Plastic knife

Latex gloves

Dust mask

Rags

17th-Century England

THE STATE BED

A 21ST-CENTURY STATUS SYMBOL IS USUALLY AN OVERSIZE FASHION ACCESSORY— the latest enormous handbag from Italy that dwarfs the model carrying it, or the massive watch from Switzerland that makes even a football player's wrist look small. In an era of ever-larger suburban homes and luxury SUVs, there is a definite sense of prestige associated with size. In 17th-century England, size was also the key attribute for advertising social standing, but the ultimate status symbol was not the handbag or the watch—it was the bed.

When George Melville became the secretary of state for Scotland, the entire Melville family breathed a huge sigh of relief. Lord Melville had spent 1683 to 1689 in exile in the Netherlands for his participation in a plot to assassinate King Charles II, and during his exile, the family estate had been confiscated. But those six years in the Netherlands turned out to be fortuitous because, while there, Lord Melville spent time at the court of William of Orange, who was secretly plotting to invade England and seize the throne. Lord Melville astutely gauged who was likeliest to win this conflict and became one of William's most loyal Scottish supporters. After William became king of England, it was not only

Daniel Marot designed this state bed for George Melville, William III's secretary of state for Scotland, and it can still be seen today at the Victoria and Albert Museum in London. State beds were usually made to accommodate royals and were lavishly upholstered in expensive fabrics and trimmings.

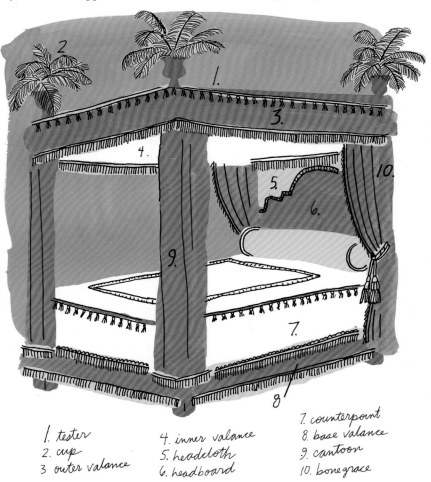

1. *tester*
2. *cup*
3. *outer valance*
4. *inner valance*
5. *headcloth*
6. *headboard*
7. *counterpoint*
8. *base valance*
9. *cantoon*
10. *bonegrace*

safe for Melville to return home from the Netherlands, but he was also amply rewarded for his loyalty. He was given the position of Scotland's secretary of state and an earldom, and the Melville estate was returned to the family.

Once back in Scotland, Lord Melville wanted to demonstrate his powerful position, and he knew the best way to do so was through a show of wealth. He quickly constructed a huge palace, and, as its centerpiece, created a state bedroom complete with a massive state bed.

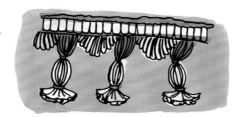

Examples of *passementerie*— the art of making decorative trimmings.

At the time, a state bed was the most effective advertisement of one's wealth and status, largely because of the cost and difficulty of obtaining textiles. In fact, a significant percentage of the textile budget for an entire home was often spent on the bed alone.

The state bed was about drama, not practicality. In fact, these extremely expensive beds were rarely used for sleeping, except on the off chance that a royal came to visit. Melville carefully chose the bed's design to appeal to King William. It was inspired by the work of Daniel Marot, the king's very own French-trained interior designer, and the canopy was hung with crimson velvet (the most expensive color for textiles). The message was clear: If King William came to Scotland, this was where he'd lay his head.

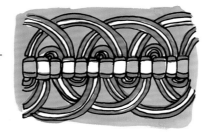

FURTHERMORE

Beds for servants were tucked into odd corners of homes, and various devices were developed to hide the bedding during the day. Personal servants often slept by the doors to their masters' apartments and acted as a sort of bodyguard.

•

In France—the decor capital in 17th-century Europe—Louis XIV would frequently gift ambassadors with a state bed as an impressive way to ensure the spread of French style throughout Europe.

•

In the 17th century, it was more lucrative to be an upholsterer than a furniture maker.

Every inch of grand state beds from the 17th century were upholstered and festooned with tassels and trimming—*passementerie*. The art of crafting decorative trimmings had been refined in Italy during the Renaissance, spread to France under the reign of Louis XIV, and reached Britain in the 17th century. *Passementerie* was used to cover unsightly seams and outline the edges and contours of a textile or bed frame; it also added to the stateliness of a grand bed, symbolizing the owner's wealth, rank, and status.

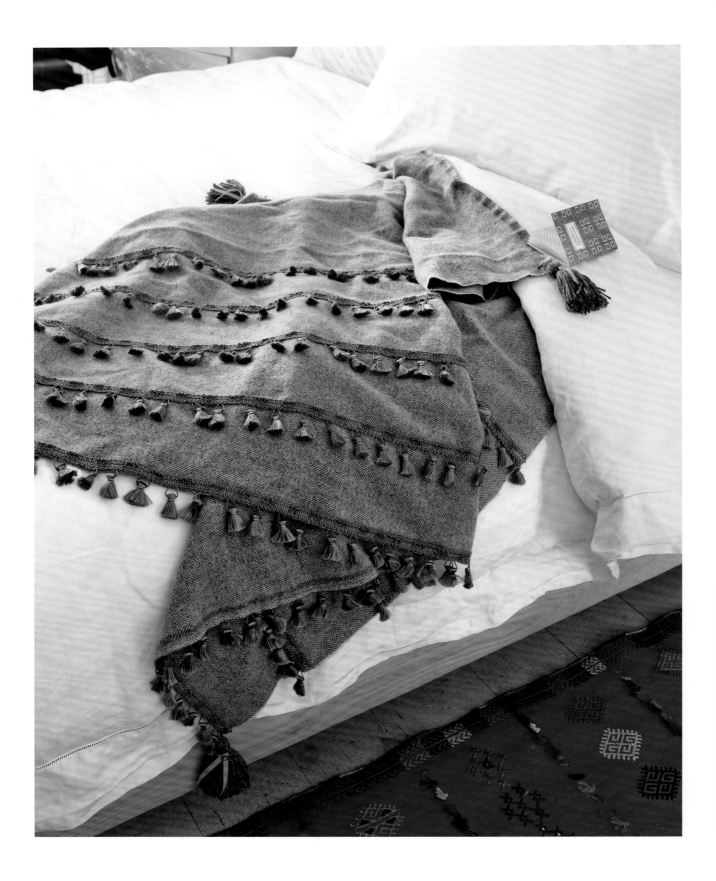

TASSEL BLANKET

designed by **RANDI BROOKMAN HARRIS**

For this cozy tasseled blanket, designer Randi Brookman Harris was inspired by the *passementerie*—fringes and tassels—that were often incorporated into state beds. This modern interpretation requires minimal sewing, but delivers a feeling of grandeur reminiscent of the impressive bed treatments from 17th-century England.

INSTRUCTIONS

1 On the raw edges of the fabric, pull threads the long way to create some fringe. (Note that the raw edges of your fabric may have been cut crooked. Pull enough threads so that you'll be able to cut a straight fringe.) Once the thread has been pulled to create fringe, trim the threads with scissors to about 1/8" (3 mm) long.

2 Now that the fringe is straight, wash and dry the wool fabric to create a softer, almost felted wool. (The washing will also take out any chemical sizing and strengthen the weave of the fabric.)

3 To create five rows of tassels, cut the tassel trim into five equal sections. Place the tassel trim in widthwise rows down the wool—selvedge to selvedge (use a ruler and tailor's chalk to create even spacing between rows). Pin the tassel trim in place, and sew with a wide zigzag stitch across the tape of each row of tassel trim to affix it to the blanket.

4 To make the tassels for the corners, wind the yarn around the cardboard several times (the more yarn you use, the fuller the tassel will be). Cut a 4" (10 cm) length of yarn and slip it beneath the wrapped yarn on one side of the cardboard. Tie it into a loose bow around the wrapped yarn. Cut across the yarn at the bottom of the cardboard, opposite the bow. Remove the cardboard. Re-tie the bow into a tight knot, cinching the yarn together as tightly as possible. Fold the fringe of the tassel in half, with the knot in the middle.

 Cut another 4" (10 cm) piece of yarn, and wrap it around the folded fringe, about 1" (2.5 cm) below the fold and knot the yarn, to create the neck of the tassel. Tie a piece of the ribbon around the tassel over the yarn knot. Knot the ribbon tightly and hide the ends of the yarn knot inside the fringe. Sew a button onto the tied ribbon to secure the knot. Trim the ends of the ribbon on the diagonal, as desired. Repeat to make three more tassels.

5 Attach each tassel to a corner of the blanket using the length of yarn on top by threading the yarn on a tapestry needle and piercing the corner of the blanket. Tie the yarn into a few knots to secure it.

FINISHED SIZE
72 x 54" (1.8 x 1.4 m)

MATERIALS
2 yards (1.8 m) of 54" (140 cm) woven wool herringbone fabric (or a wool blanket of your choice)

10 yards (9.2 m) of tassel trim

Thread in a contrasting color

8 yards (7.3 m) of yarn

2 yards (1.8 m) of 1/4" (6 mm) ribbon to match contrasting thread on blanket, cut into 4 pieces

4 buttons

TOOLS
Seam ripper

Scissors

Washing machine and dryer

Ruler

Tailor's chalk

Straight pins

Sewing machine (If you don't have a sewing machine, you can always pin the trim to the fabric as described and take it to a dry cleaner or tailor to be stitched in place. Or use a fusible bonding web like Stitch Witchery to glue the tassel in place.)

5" (13 cm) square of cardboard

Large-eyed tapestry needle

CHINOISERIE STYLE

WESTERN FASCINATION WITH EASTERN GOODS DATES BACK TO THE ROMANS, WHO went crazy for the Chinese silk that reached them along caravan trade routes between China and the Roman Empire. When China shut its doors to Western-ers in AD 878, just before the fall of the T'ang Dynasty, fascination with the East only intensified. A few European merchants were still allowed to trade with the East, and most of them came from Venice. Venetian merchants were famous worldwide for bringing exotic valuables—spices, gems, fabrics, salt, wax, drugs, ivory, wool, gold, and pearls among them—back to Europe. So it's not surpris-ing that the appetite for Chinese goods in the 13th century was escalated by a Venetian: Marco Polo.

Seventeen-year-old Marco was taken to China by his father and uncle, who were both adventurous merchants. In 1271, he became a trusted servant to the Mongolian overlord and ruler of China, Kublai Khan, the grandson of the fierce Genghis Khan. For the next twenty years, until 1292, Marco traveled with

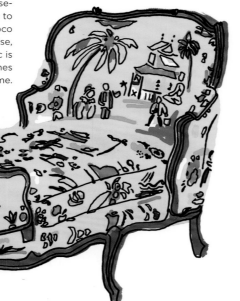

Chinoiserie translates to "Chinese-esque." The style went on to become a key element in rococo design; for instance, in this chaise, the Chinese-inspired fabric is complemented by the curvy lines of the wood frame.

Kublai Khan all through the Mongol empire and China. After Marco's jour-ney through Asia, he returned home to find Venice at war with Genoa, and he was unluckily captured as a prisoner of war. While imprisoned, he dictated his stories to his cellmate (who just hap-pened to be a skilled romance writer) and the resulting book, *The Travels of Marco Polo*, provided Europe with its first tantalizing glimpse of China—and the luxuries that could be easily carried back on merchant ships. Thus, even from captivity, Marco inflamed Euro-pean desire for Chinese goods.

All of Europe wanted a piece of the action. By the 16th century, the Portuguese were winning the Chi-nese imports race. Instead of trying to compete, Queen Elizabeth I licensed privateers to plunder Portuguese and Spanish ships and bring the Chinese goods to England. While piracy may have been a good short-term solution to the problem, it wouldn't sustain the appetite of Britain for long. In 1600, Queen Elizabeth granted the East India Company, which was made up of merchants from London, a charter that gave them a monopoly on selling imported Chinese goods in Britain. This move would completely alter the drink, dress, and artistic taste of Britain's upper class. Goods like silk, tea, and Chinese art were now

more readily available, but they were expensive and still difficult to obtain, despite the open trade routes. To fill this niche, savvy craftsmen began to imitate Chinese wares in an effort to capture a piece of the unsatisfied market.

The most difficult product to imitate proved to be porcelain—and porcelain, of course, was one of the most desirable objects. Porcelain from the East was so precious that objects would frequently be mounted in silver or gilt bronze to protect the porcelain and enhance its value (for instance, a porcelain bowl would be given a silver base and feet).

By 1638, more than three million pieces of porcelain had been brought from China to Europe, yet demand was still unfulfilled. Chinese goods had become symbols of wealth and power, and many of the elite were determined to outfit entire rooms in porcelain, with vases clustered on the fireplace mantel and mounted dishes climbing up every available inch of wall space.

Europeans knew how to produce earthenware, but the secret to creating thin, translucent porcelain remained a mystery. To appeal to consumers who were obsessed with the Far East but couldn't get their hands on the goods, many craftsmen decorated European-made goods—such as earthenware pottery—with Chinese-inspired imagery. This mixture of European and Chinese design was a fantasy version of China, featuring lush landscapes with fanciful pavilions and exotic birds, and products from this era in this style are known as chinoiserie.

Soon, chinoiserie became an acceptable (and desirable) answer to the supply problem, but it didn't solve one issue: The craftsmanship in China was still far superior to that in Europe. In order to create higher-quality chinoiserie pieces, European designers sent the blueprints for their ideas to porcelain, textile, and furniture manufacturers in the East. The combination of influences—Chinese inspiration and European design—resulted in a stylized look that hardly resembled the traditional aesthetic of either culture, but was appealing to European sensibilities.

At the height of the chinoiserie craze, merchants purchased porcelain from China and then had it mounted in silver or bronze. The resulting pieces were extremely expensive, but even so, the volume of trade was enormous.

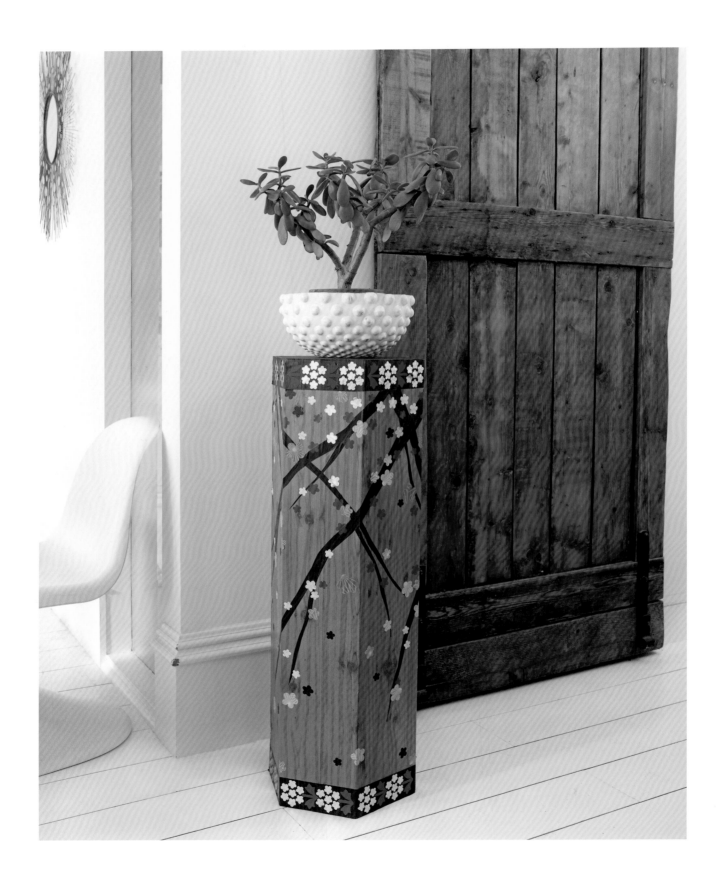

CHINOISERIE PEDESTAL

designed by **TODD OLDHAM**

Chinoiserie, like its cousin rococo, was flowery and feminine. The exotic flowers and birds that often typified the look represented a version of China that seemed very mysterious and alluring to 18th-century Europeans. For this chinoiserie-style pedestal, Todd Oldham took inspiration from cherry blossoms. The design looks painted but is actually applied using contact paper cut into floral shapes. You can use this technique on any smooth surface, such as a dresser, nightstand, or even a small jewelry box.

INSTRUCTIONS

1 Prepare your flower motifs by tracing the modified cherry blossom patterns (see template on page 119) onto the back side of the contact paper. For the branches, it's best to draw the shapes freehand on a long sheet of contact paper, keeping the design simple. We made our branches 1" (2.5 cm) wide and 36" (91 cm) long. Place the contact paper on a cutting mat and carefully cut out the shapes using an X-Acto knife.

2 Prepare the surface of your pedestal by wiping it clean.

3 Apply the contact paper cutouts one at a time, smoothing out any wrinkles as you go. To flatten bubbles, you can puncture the sticker with a utility knife and then smooth it out. If you don't like the placement of a sticker, you can easily peel off the cutouts a few times before the adhesive is lost. If you'd like to plan out your design, you could attach each sticker to the pedestal with a small piece of painter's tape before pulling off the backing and adhering it permanently. Continue to add stickers until your motif is finished.

4 In a well-ventilated area, seal the surface of the pedestal by applying several light coats of a spray polyurethane until smooth. Follow the package instructions for drying time between coats.

MATERIALS
18" (46 cm) wide patterned adhesive contact paper (or adhesive sheets printed with pattern of your choice)

Wooden pedestal (shown 39 x 12" / 99 x 30.5 cm)

TOOLS
Cutting mat

Pencil

X-Acto knife and/or scissors

Polyurethane spray

A BRIEF HISTORY OF GREENHOUSES

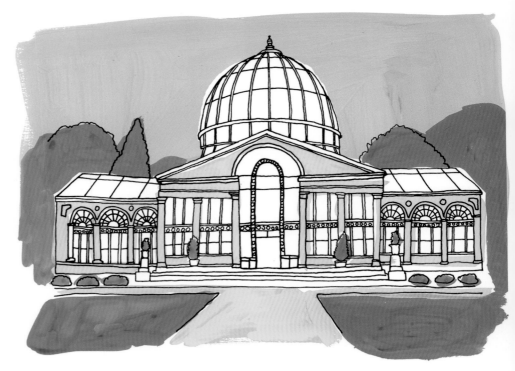

The words *greenhouse*, *orangerie*, and *conservatory* are often used interchangeably. An orangerie is similar to a greenhouse, but the name reflects the building's original use: housing citrus trees in the winter. A conservatory is typically a glassed-in room attached to the house and used as a greenhouse or sunroom.

WITH GROCERY STORE AISLES OVERFLOWING WITH FRUIT FROM ALL OVER THE world, it can be difficult to remember that, until relatively recently, out-of-season fruit was a luxury reserved for the extremely wealthy. For us, this phenomenon is largely possible because of shipping, but for our predecessors, this luxury was made possible by the use of greenhouses. The Romans were the first to realize that if plants received ample light and had warm roots, they produced earlier crops of fruits and vegetables. To create these ideal conditions, Romans filled "hot pits" with manure, which kept plant roots warm. To protect the plants from the elements and provide the light they needed to encourage growth, they used mica, a type of rock that, when cut into thin sheets, is relatively transparent.

Over time (and with technological advances in glassmaking), greenhouses became a very important element of garden design, particularly in the Italian villas of the Renaissance. The highlight of most Renaissance gardens was the movable citrus trees that lined the garden walkways in warm weather and, in the winter, were moved to an orangerie, a greenhouse just for citrus trees. These Italian Renaissance gardens and greenhouses astonished travelers from all over Europe who returned home with not only new techniques and ideas for garden structures, but also with the plants themselves (which is how citrus trees made their way from Italy to chillier regions like France and England).

From the time of the Renaissance to the 18th century, greenhouses only increased in popularity. By the 17th century, the greenhouse and surrounding landscape were just as important as the interior decoration of the main house. For meals in many of these great houses, servants would carry fruit trees from the greenhouse into the dining room, allowing guests to pluck their own cherries or oranges straight from the branches. Louis XIV particularly admired his greenhouse at Versailles, and when he personally mapped out the tour of the palace, he insisted that visitors view the gardens following his specified route—even going so far as to direct them to the best possible vista for viewing the greenhouse. Several orange trees dating from Louis XIV's time still stand at Versailles, and each October, they are brought back into the orangerie for winter.

Nathaniel Ward was the plant-obsessed Victorian who first discovered terrariums, which are glass-covered environments in which only certain types of plants will thrive.

FURTHERMORE

Lancelot "Capability" Brown's trademark landscape feature was a smooth, rolling grass lawn that ran straight up to the house, replacing the more formal English garden. Americans who traveled to England in the 18th century returned home inspired by their tours of the great houses, and the American front lawn is a descendant of these rolling vistas.

•

Even with the advent of worldwide shipping in the 20th century, greenhouses are still used by gardeners to extend the growing season for plants. Today's greenhouses are usually constructed with polyethylene film instead of glass.

The English were just as greenhouse-crazy as the French. English landscape architect Lancelot "Capability" Brown was instrumental in increasing the popularity of greenhouses, incorporating them into approximately 170 gardens in Britain. Many descendants of his early greenhouse plants still bear fruit, and the vinery at Hampton Court palace in England, which was planted in 1768 under Brown, still produces a dessert wine.

In the 19th century, twenty-three-year-old Joseph Paxton took greenhouses to the next level when he was appointed head gardener at the Chatsworth House in England. He arrived to find a small cluster of glass houses that provided insufficient space for the plants he was avidly collecting, so he designed and built a massive cast-iron-and-glass greenhouse. Finished in 1841, the 67-foot-tall (20.4 m), 34,000 square-foot (10,363 m²) structure was the largest glass building in existence, and at night, it was illuminated by 12,000 lamps. A couple of years later, Queen Victoria and Prince Albert paid a visit to the massive greenhouse, driving an open carriage down the central aisle. It made such an impression that Queen Victoria knighted Paxton in 1850 and Prince Albert commissioned him to design the structure for the 1851 Great Exhibition in London. The Crystal Palace, as it was named, wowed visitors even before they went inside to see the exhibits (see page 78).

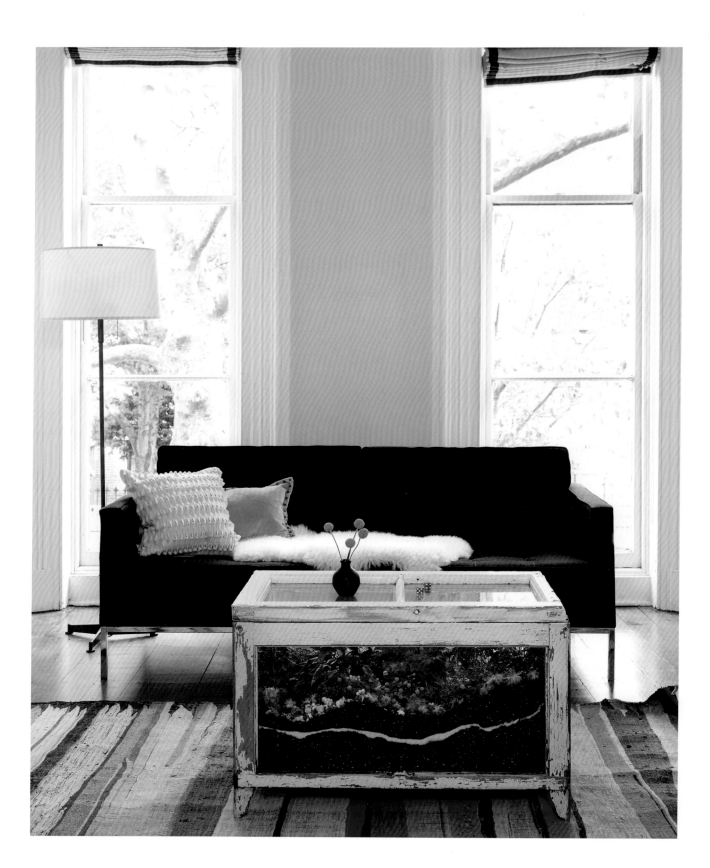

GREENHOUSE COFFEE TABLE

designed by STUDIO CHOO

For this project, the designers at Studio Choo created a miniature greenhouse that does double duty as a coffee table. To find the supplies, you can explore your local salvage yard, buy your materials new at a hardware store, or use a combination of both—the choice is up to you! While the table may resemble a greenhouse, its closed top makes it function more like a terrarium, so fill up the coffee table with terrarium-friendly plants (see step 8). To fill it with other types of plants, drill drainage holes in the bottom, move it outdoors, and leave the top off (or propped up).

INSTRUCTIONS

1 Thoroughly clean all windowpanes. Use a stiff brush to gently scrape any chipped paint from the wood, and use a razor blade to scrape any excess paint or dirt from the glass.

2 Measure the four floorboards. Then measure the height of one of the long side windowpanes. You will need to order two pieces of custom-cut glass that are the same width as (or slightly narrower than) the floorboards, and the same height as the windowpane.

3 The bottom piece of plywood needs to fit inside the four side walls. To determine its size, measure the length and width of the top windowpane. Then measure the thickness of each of the side windowpanes. Subtract the width of the long windowpanes from the width of the top windowpane, and subtract the width of the short windowpanes from the length of the top windowpane. Have plywood cut to these dimensions.

4 Using screws and a power drill, begin to build a box with the plywood and four windowpanes. Attach the plywood to one of the long side windows first, then to the other long side window. Attach one of the floorboards, with the interlocking channel facing up, to each side of the plywood bottom; then screw the floorboards into the long side windows.

5 The tongue-and-groove floorboards have slots for the custom-cut glass to be inserted. Carefully slide your custom-cut glass into each end of the coffee table. Then place the other two tongue-and-groove side pieces on top of the glass. Use screws to attach the top tongue-and-groove pieces to the long window pieces.

6 Attach the top windowpane to one of the long sides using hinges and screws.

7 With the top window open, seal any cracks between the windows, scrap wood, and plywood with silicone. Then apply a waterproof varnish to the plywood and any wooden surfaces on the inside. Let the silicone and varnish dry thoroughly.

8 Place a few inches of gravel on the bottom of the coffee table (this is important for drainage). If the table is going to be outside, you can drill drainage holes into the plywood so the water will drain out the bottom. Sprinkle charcoal on top of the gravel. Buy an appro-

MATERIALS

For the long sides:
2 windowpanes of the same size—ours are 30" long by 15" tall (76 x 38 cm); if you want your window to sit up on legs, like ours does, look for double-hung sash windows or buy short table legs from your local hardware store

For the top: 1 windowpane the same length as the two long side panes

For the short sides: 4 tongue-and-groove floorboards (the length of each piece must match the width of the top windowpane)

2 custom-cut panes of glass (see step 2)

For the bottom: Plywood, cut to size (see step 3)

Screws

2 hinges

Clear silicone sealant

Waterproof varnish

Gravel (you'll need enough to cover the entire bottom of the coffee table to a depth of about 3" / 8 cm)

Planting charcoal

Planting mix

Variety of plants (see step 8)

(See Tools list on page 45)

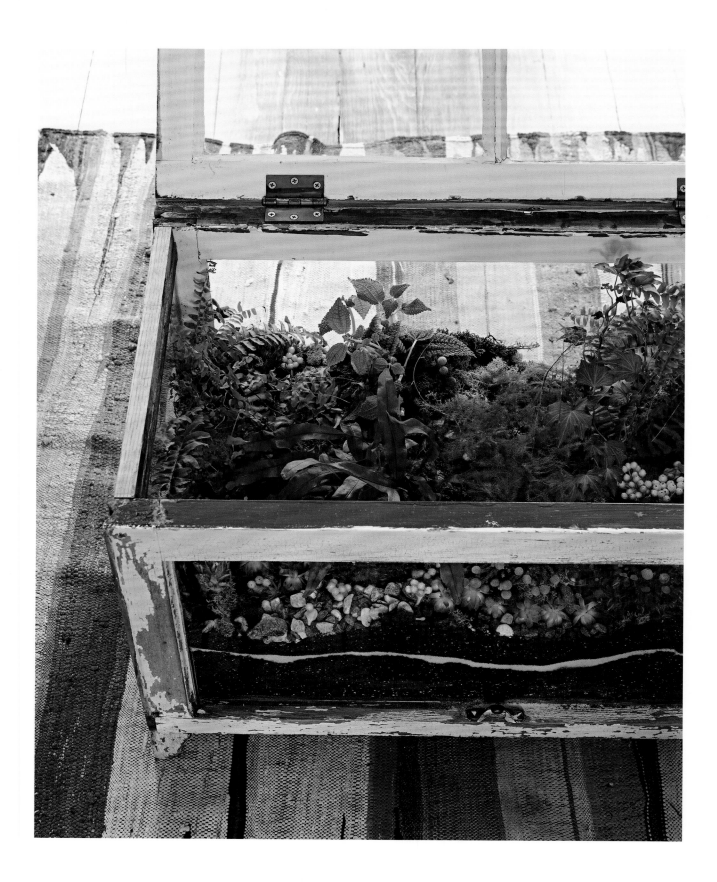

priate planting mix for the types of plants you are going to use (for instance, succulents and cacti like a sandier soil) and scoop a few inches of soil into the table. Add any plants you like. We've used kangaroo fern, hens and chicks, selaginella, Boston fern, wire vine, moss, begonias, and crossandra. You want to be sure that your plants have similar environmental needs.

9. Caring for your "greenhouse": If you notice condensation on the glass, prop the lid open to allow for air circulation. Check the moisture level of the terrarium about once a week. You'll only need to water the plants when the soil feels dried out. Be sure to keep your terrarium clean by removing any dead leaves or debris and by occasionally cleaning the glass.

TOOLS

Stiff brush

Razor blade

Tape measure

Electric drill

Paint brush

GROTTOES

WHEN IT CAME TO BRINGING HOME SOUVENIRS FROM A TRIP, NO ONE WAS AS fanatical as the 17th- and 18th-century Brits. But instead of the postcards, magnets, and T-shirts we might bring home today, these travelers' souvenirs were much more extravagant—and so were the vacations. At that time, it was common for wealthy British men to go on a sort of intellectual pilgrimage, visiting sites of classical antiquity in France and Italy. The trip, which became known as the Grand Tour, lasted anywhere from a couple months to a couple years and was considered the culmination of a liberal education. It followed a prescribed itinerary of must-see cities, sites, and activities, such as fencing in France, the Renaissance art galleries in Florence, and opera in Naples. While the tour was designed to soak up the culture of the ancients, for many, it was one big shopping trip. Upon returning home, many travelers had to construct galleries to hold all the ancient objects, books, and paintings they had accumulated while on the road, and some even set about re-creating architectural elements they had delighted in on their tour, which was how the garden grotto became popular in England.

Seashells were a major component of grotto design with thousands arranged in decorative patterns covering grotto walls.

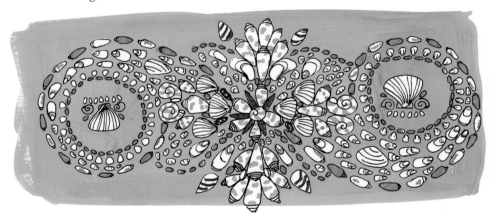

A grotto is technically an artificial cavern, and the first grottoes date back to the ancient Romans. These were usually built above a spring or fountain in a private garden, and they were used as a place to seek the Muses. As grottoes became more popular in Europe, however, they took on a more frivolous purpose, becoming a delightful place to hold impromptu, casual parties.

Englishmen on the Grand Tour, infused with passion for classical art and architecture, loved the idea of re-creating classical Roman architecture in their backyards. The 18th-century poet Alexander Pope was one of the first Britons to incorporate a grotto into his garden. He dug a tunnel beneath the road that linked his house to the garden and decorated it with seashells, glass, and mirrors. Over the next twenty years, he refined, enlarged, and decorated his grotto until it had multiple rooms and passages.

Most English grottoes were built with local bricks that were then covered in rustic rocks. The interior would have been decorated with shells, mirrors, and glass, with each piece glued on individually by hand. Since seashells were often a major component of grotto decoration, a shell-collecting mania took Britain by storm in the 18th and 19th centuries, and many builders spent small fortunes importing shells from all over the world. Not only was the hobby of decorating grottoes expensive, but it also involved a high level of precision and could take years to complete.

Though men may have been the ones to bring home the concept, grotto making became a popular hobby for middle- and upper-class women. Since they did not work and had servants to do the cooking and cleaning, they had plenty of time on their hands to devote to the painstaking decoration of a grotto. Once it was complete, neighbors would be invited over to examine the workmanship and critique the design. In fact, many grottoes were simply created as a testament to a person's wealth and status, and featured extravagant details like fireplaces and custom-made furniture.

Grotto construction was also a form of entertainment for 18th-century French nobility who were bored with traditional diversions and had money to burn. Marie Antoinette spent huge sums on landscaping improvements at the Petit Trianon, a small hideaway château on the grounds of Versailles on which she created an English-style garden and constructed a private grotto. Marie Antoinette was actually inside her grotto when, in 1789, she heard the news that would spell her doom: The French were rebelling and descending on Versailles.

Grottoes continued to become more and more ornate, culminating in the grotto built by King Ludwig II of Bavaria in 1876. Ludwig was a bit of an eccentric, and in the park surrounding Linderhof Palace, he liked to be rowed over his artificial underground lake in a boat shaped like a golden swan. He wanted to build a fantastical grotto similar to the Blue Grotto of Capri, which is a natural sea cave that, due to a trick of sunlight passing through a hole, is flooded with brilliant blue light. To achieve this effect, Ludwig's Blue Grotto was equipped with electric spotlights (a new technology for the day), which would bathe the grotto in pink or blue light to create the illusion of a thunderstorm. It was a dramatic end to the fashion for garden caves.

FURTHERMORE

In September 1777, Marie Antoinette hosted a party to celebrate the completion of the Temple of Love, a small neoclassical pavilion on the grounds of Versailles. The party was held in a temporarily constructed village complete with fairgrounds, a marketplace, food stalls, and a tavern where the ladies of the court poured drinks and the queen passed out lemonade.

•

The Greeks considered natural rock grottoes to be the dwelling places of nymphs and deities, and the water that emerged from the rocks to be sacred.

GROTTO JEWELRY BOX

designed by ERICA DOMESEK

To create this exquisite jewelry box, Erica Domesek channeled the creative Victorians who carefully decorated their garden grottoes. The decorations shown here, including seashells and plastic insects, are a fun nod to the Victorian obsession with collecting natural specimens and incorporating them into their homes.

INSTRUCTIONS

1 In a well-ventilated area, cover a flat surface with newspaper. Lay the plastic bugs, shells, and case on the newspaper and thoroughly spray with gold spray paint. Once completely dry, turn the items over to spray the other side. Spray-paint the inside of the case as well.

2 Once the paint is dry, lay the bugs and shells out in a design of your choosing on top of your case. Set aside three larger shells for the inside of the case. Once you have created a design you like, apply small amounts of glue to the underside of each bug and shell, and place it back in its spot on the case. Hold it in place for approximately 15 seconds, until secure. Leave the case to dry overnight before moving it.

3 Once the case is completely dry, attach the three shells you set aside to the inside of the case. To attach the shells, apply a generous amount of glue to the back of each one and position as desired. These will serve as hooks for your jewelry.

4 Let the entire project dry for a full 24 hours and then hang the box using picture-hanging strips.

MATERIALS
Plastic bugs (we used 6)

Seashells of varying sizes (we used 44)

Small suitcase or lunchbox, approximately 8 x 12" / 21 x 31 cm (see Resources, page 142)

Adhesive picture-hanging strips

TOOLS
Newspaper

Gold spray paint

Super Glue

Early 18th-Century France
ROCOCO STYLE

SPENDING A COZY WINTER'S EVENING TUCKED INTO A FAVORITE ARMCHAIR WITH A good book might seem like an inalienable right, but, in fact, the concept of the armchair (and comfort in general) is relatively new to the modern home.

Prior to the 18th century, even the rich and famous lived in uncomfortable conditions. Up until this point, styles had been dictated by kings wishing to visually express their power and magnificence, which typically appeared in the form of cavernous, imposing rooms filled with expensive furniture. There was no thought given to how these rooms would be lived in—no discussion of storage space, lighting, heating, convenience, softness, or privacy. Louis XV, who reigned from 1730 to 1760, was the first king for whom comfort was even a consideration. His grandfather, Louis XIV, had lived his entire life in the public eye, with every moment—from waking in the morning, to eating, to going to bed at night—spent in front of an audience. Rather than accept that type of life, Louis XV created a smaller, cozier parallel universe within the walls of Versailles to which he could escape. Among these hidden rooms were a dining room, a second bedroom, and even a private kitchen where he could practice the art of pastry making with Versailles's master pastry chef. All of these rooms were invisible to the public so that at any moment, he could escape from prying eyes.

Just because comfort was important to Louis XV didn't mean that aesthetics went out the window. During his reign, the flowery rococo style was the rage in France. It was considered extremely modern for its time, ignoring the rules of classical architecture and instead drawing playful inspiration from natural elements like rocks, shells, and flowers, as well as Chinese design and asymmetry. The most recognizable decorations of the rococo period were looping C-scrolls and S-curves, which appeared in direct contrast to the balanced, straight lines and geometry of earlier styles. If styles had genders, rococo most certainly would have been feminine.

Louis XV was known for his love of two things—hunting and women—and Madame de Pompadour was an object of his female fixation. Born Jeanne-Antoinette Poisson, Madame de Pompadour was one of a string of royal mistresses, and in this role, she was challenged to keep an easily bored Louis XV entertained. In addition to countless suppers, festivities, and performances, de Pompadour distracted the king by embarking on a series of building and redecorating projects. Although she was born a commoner, Madame de Pompadour developed impeccable taste and became a trendsetter in her time. She was a fervent supporter of French industry, and the classic pink of Sèvres porcelain—rose de Pompadour—is named after her.

Like Louis XV, Madame de Pompadour also delighted in the early 18th century's newfound obsession with comfort, and she had a hand in popularizing the practical furniture that evolved from this period, such as side tables,

FURTHERMORE

Madame de Pompadour had many apartments in a number of different residences. After her death, it took a team of notaries a full week to compile a list of her possessions.

•

The pompadour hairstyle is named for Madame de Pompadour, who wore her hair swept up into a pouf high over her forehead.

In the rococo style, C-scrolls and S-curves abounded, and every object in the room coordinated perfectly with the other objects. While coordination was important to the design, so was asymmetry, which lent an overall organic feel.

A *chaise voyeuse* featured an elbow pad, so a person could stand behind the chair and rest his elbows while watching a game of cards.

nightstands, and comfortable armchairs. Until this time, furniture in the homes of the wealthy was for display only, and there would only be a few pieces in each room. But suddenly, an array of furniture became available that was meant to be *used*, and in styles to suit nearly every situation and fashion choice. A *cabriolet à coiffer* was a chair with a dip in its center-back that allowed for the placement of an exquisitely coiffed hairdo. Another style of chair was the *voyeuse*—named for the pad along the top of the chair where a bystander could rest an elbow while watching a card game. But the most important piece of furniture perfected during the 18th century—and one that is still seen in most Western households today—was the sofa. The sofa was first conceived as a double-size armchair called a *canapé*. It was a little stiff, but it quickly morphed into the first piece of furniture to feature upholstery on all sides.

Architects began to get into the act, designing rooms and furniture to work together harmoniously, and then decorating the rooms in delightful rococo style. A curved sofa might be designed to fit perfectly against the walls of an oval room and then accented with elaborately carved wood moldings. Furnishing would be covered in floral patterned silks to match the swirling curves of the room, and floor-to-ceiling windows would be highlighted by draperies in warm pastels, embroidered with foliage. The style was light, airy, and, above all else, comfortable.

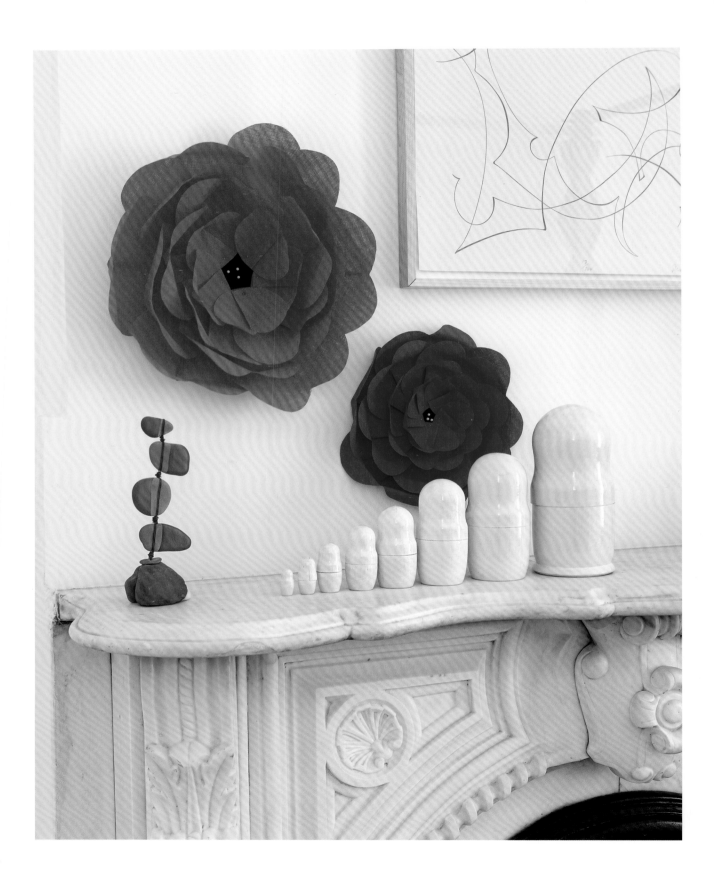

WALLFLOWER HANGINGS

designed by EMERSONMADE

Floral motifs abounded in traditional rococo rooms, and this fabric wallflower project is a modern spin on the classic rococo flower. To make them, EmersonMade used starched linen in colors so vibrant and feminine, they would surely have pleased the biggest rococo fan of all, Madame de Pompadour.

INSTRUCTIONS

1 Following the instructions on your spray starch, starch the linen pieces so the fabric will be quite stiff and the flowers will hold their shape.

2 After choosing the size flower that you'd like to make, photocopy the petal shape from the template (see page 120) at 100% and cut it out.
 Trace the petal shapes onto the linen, then cut each petal out. (See the chart on page 120 for how many of each cut petal you'll need for your size flower.)

3 To make the cardboard base for the flower, use the compass to measure and mark a circle for the size flower you are making: small, 5 1/2" (14 cm); medium, 7" (18 cm); large, 8 1/2" (22 cm). Using scissors, cut out the cardboard rounds, then trace around the cardboard circle onto felt. Cut the felt and attach it to the cardboard using hot glue.

4 Hold a petal with both hands, thumbs placed just below the center point, and create a small overlap. Hot-glue this overlap into place. Repeat to create all the petals. When you get to the smallest petals, instead of glue, secure the overlap by sewing an X at the bottom-center of each petal using gold thread.

5 For the first layer of petals, place one of the largest petals 1/2" (13 mm) in from the edge of the felt and glue it onto the felt round. Continue placing and gluing petals counter-clockwise around the felt edge. (Refer to the chart on page 128 for the petal layout in each layer.) Do the same for each consecutive circle of petals, moving each layer roughly 1" (2.5 cm) closer to the center. When you reach the last layer, place petals so they frame the felt center in a pentagon shape. This pentagon should measure 1" (2.5 cm) for the small flower, 1 1/2" (3.8 cm) for the medium flower, and 2" (5 cm) for the large flower. Insert three yellow pushpins in the pentagon area.

6 To finish your wall hanging, use a hole punch to create two holes about 1" (2.5 cm) apart in the cardboard round. Cut a piece of wire to about 6" (15 cm), depending on your hanging preference, and slip the ends of the wire into the holes, bending the wire so that it catches. Your wire will now be a hook for hanging.

FINISHED SIZES
Small: 12" (30.5 cm)
Medium: 14" (35.5 cm)
Large: 16" (40.5 cm)

MATERIALS
Heavy spray starch

Linen, in bright colors:
1/2 yard (.5 m) for small flower,
3/4 yard (.7 m) for medium
flower, 1 yard (.95 m) for
large flower

18 x 36" (46 x 91.5 cm)
piece of cardboard

1/2 yard (.5 m) felt for
the flower center

Gold thread
(for sewing denim)

Thin wire (for jewelry
or flower arranging)

Yellow pushpins

TOOLS
Pencil or pen

Scissors

Compass

Ruler

Hot glue gun with glue sticks

Sewing needle

Standard hole punch

THE SECRET COMPARTMENTS OF LOUIS XVI

DURING THE REIGN OF LOUIS XIV IN THE 17TH AND EARLY 18TH CENTURIES, EVEN the most mundane tasks of daily life were transformed into spectacular ceremonies. Versailles was the location of the French court and center of the French government; as such, it was home to between 2,000 and 4,000 inhabitants. Louis XIV required the nobility to be present at all times, and they brought cooks, grooms, maids, tailors, and all manner of servants with them. During this era, the palace was as cramped as an apartment block—so much so that some members of the nobility were only allotted two-room apartments. The palace was even open to tourists, so for major state events or holidays, the usual couple thousand could easily swell to 10,000. Anyone was welcome to watch the public dinner (*grand couvert*) at Versailles as long as they were equipped with a sword, and much like a swanky Manhattan restaurant where a dinner jacket is required, swords were available at the gates for the unprepared to borrow. More intimate tasks, such as the *levée* (getting a royal ready for the day) and the *coucher* (putting a royal to bed) were elaborate, protocol-filled ceremonies with every task assigned to a specific rank of the nobility.

While Louis XIV lived for the spotlight, later generations began to embrace a lifestyle of comfort and privacy. By the time Louis XVI became king in 1774, it was assumed that royals had private lives outside of the public eye. Just as soon as the elaborate bedding ceremony was over, Louis XVI's wife, Marie Antoinette, would escape from the formal reception bedroom through a door hidden behind elaborate paneling. Behind these walls, she had a network of smaller rooms with low ceilings—a tiny, cozy bedroom, a little library, and a place to have private dinner parties with only a handful of people.

1–4: The secret passage that links the queen's stateroom to the king's (Marie Antoinette escaped from the Paris mob using this route.)

5: The toilet

6: The sofa room—where Marie Antoinette would frequently take a mid-afternoon nap

7: The library

8: The library extension

9: The Gold Room—a room for music and relaxation

10: A small room decorated with painted panels

11: *Pièce des bains*—a room for linen storage and drying and warming towels

12: *Chambre des bains*—for bathing

13: Antechamber

14: Staircase

A–F: The grand staterooms

a: Apartment of the Duke de Duras

b: King's apartments—private rooms for the king

I–II: *Cour de Monseigneur*—interior courtyards

Floorplan of the Queen's private apartments, 1789 (first floor)

Secret compartments, secret rooms, and elaborate locks were all a part of 18th-century life. In a time without trustworthy bank vaults, furniture built with secret locked drawers was one of the few ways to ensure that valuables would remain safe. And it wasn't just jewels that needed protecting—secret love affairs abounded, so love letters needed a secure hiding place, as did documents relating to political intrigue.

The cabinetmakers of the time created furniture with elaborately hidden compartments and drawers. Many of the secret compartments were hidden behind false panels, or were invisible until revealed by the touch of a secret button or lever, and if a prowler discovered the false compartment, a lock would make sure that he couldn't get inside the drawer without a key. During the 18th century, there were numerous technological advances in lockmaking. For example, "detector locks" could keep count of how many times the device was unlocked, so the owner knew if the key had been used in his absence. And one elaborate combination lock was advertised as being able to grab the wrist of and fire a pistol at anyone who used an incorrect combination.

Lockmaking was considered an art form, and even Louis XVI crafted his own locks as a hobby. Although his skills were quite accomplished, he still needed the help of the royal workshop's master locksmith, François Gamain, for his most delicate jobs. Sensing the growing angst of the revolutionaries, Louis XVI charged Gamain with crafting a small iron chest where he could keep documents hidden beneath the floor. Gamain had worked for the royals for twenty years, but was not as trustworthy as the king had supposed—he later turned the key over to the revolutionaries and informed them of the chest's location. Once unearthed, the documents were used as evidence in the king's trial, which eventually led to his execution for high treason.

When closed, this desk appears to be a simple writing table, but when the top is opened, a book rest springs forward, and when the drawer is pulled out, secret compartments are revealed on the sides of the drawers.

SECRET WINDOW CABINET

designed by LADIES & GENTLEMEN STUDIO

For this project, designers Jean Lee and Dylan Davis created a secret bathroom cabinet using a vintage landscape painting and a mock window treatment. Though your medicine cabinet essentials may not be as top-secret as the jewels and letters of 18th-century French royals, it's still nice to have a place to conceal your creams, potions, and serums. For lots of landscape painting options, check the New York Public Library's online digital gallery; many of the images are free to download (see Resources, page 142).

INSTRUCTIONS

1 Decide on a photograph or artwork with a landscape scene to use on the outside of your cabinet. It could be a vintage oil painting or an enlarged photograph of your own. It should fit inside the frame of your medicine cabinet door. (If it doesn't fit exactly, cut it to size using the utility knife.)

2 Examine the door of your medicine cabinet. If possible, remove the mirror. Place your artwork under the Plexiglas and insert both items into the mirror frame, then reassemble the cabinet. If your mirror frame cannot be disassembled, bend and slide the artwork and Plexiglas between the frame and mirror. Use a bit of spray adhesive on the back of the artwork to secure it to the mirror.

3 Use a stud finder to locate the wall studs. Attach the cabinet to the wall, following the cabinet manufacturer's instructions.

FINISHED SIZE
15 x 19 x 5"
(38 x 48.5 x 12.5 cm)

MATERIALS
Landscape artwork or photograph to fit cabinet door's frame

Medicine cabinet with a framed mirror door (see Resources, page 142)

Spray adhesive

Screws for attaching cabinet to wall

1/32" (7 mm) thick clear acrylic (Plexiglas) to fit mirror frame, purchased in the small sheet department of a hardware store

TOOLS
Utility knife

Tape measure

Stud finder

Screwdriver

Level

NOTE
Those more advanced at DIY home repairs may want to purchase a cabinet that can be installed "in-wall" between two studs. By cutting a space for the cabinet in your drywall, you can recess it into the wall and make it appear even more like a real window.

JOSIAH WEDGWOOD

Josiah Wedgwood featured Greek figures in much of his work, in keeping with the fashion of 18th-century neoclassical design.

OVER THE LAST COUPLE CENTURIES, THE NAME WEDGWOOD HAS BECOME SYNONY-mous with fancy porcelain—the kind that you put on your wedding registry or, if you're lucky, inherit from your grandmother. Since the company's founding in 1759, Wedgwood pottery has graced the tables of illustrious homes throughout the world, from the palace of Russia's Catherine the Great to Theodore Roosevelt's White House.

The story of Wedgwood is a great rags-to-riches tale. The company's founder, Josiah Wedgwood, was born in England in 1730, the twelfth child in a family of struggling potters. Traditionally, all of a family's financial backing would go to help the firstborn son get a leg up in the world. Josiah—the youngest of five boys—was an unlikely candidate to receive much in the way of support, but he was luckier than most, attending school until he was fourteen (most boys from poor families only attended school until they were nine). After that, he became a pottery apprentice to his oldest brother, Thomas. Shortly after he began his apprenticeship, he contracted smallpox. Although he recovered, the smallpox weakened his knee and made it difficult for him to work the potter's wheel. What should have been detrimental to his career ended up being the catalyst for his success: As a result of his handicap, Josiah turned his attention to designing pottery rather than making it.

Success didn't come quickly. It took Josiah seven years and several different partnerships before he was able to establish his own firm. Initially he produced the typical "greengrocery" wares of the time, which included pottery shaped like cabbages, melons, and other produce. Although the form of the pottery wasn't unique, these vessels were decorated with Josiah's "grass green" glaze—the first of many glazes he created that would, over time, distinguish Wedgwood pottery from others. The success of these glazes taught Josiah the importance of innovation and branding.

FURTHERMORE

Josiah Wedgwood's eldest daughter, Susannah (nicknamed Sukey), was the mother of Charles Darwin. Some say it was the Wedgwood family money that gave Darwin the time necessary to formulate his theories.

●

Josiah Wedgwood built one of the first factories in the world and was among the first to put Adam Smith's theory of division of labor into practice.

●

Everyone who was anyone had Wedgwood pottery—even Jane Austen owned a set.

Like most entrepreneurs, Josiah spent a significant amount of his time working to improve his business, but he also had another aim: He was in love with his third cousin, Sally Wedgwood, and wanted to marry her. Since Sally was wealthy (she stood to inherit £20,000, or $2 million today), there was a slight hitch in this plan: Her father had hoped to see her settled with someone who made more money than a common potter. It took some convincing, but the couple married in 1764; Josiah was thirty-four and Sally was thirty. Marrying Sally would prove to be one of Josiah's best business decisions. Not only did she bring with her a sizable dowry, which gave the Wedgwood pottery a welcome cash infusion, but she also proved to be an adept partner, offering suggestions on design and taking notes while Josiah conducted his experiments.

In the 1750s, as excavations of the ancient Italian cities of Herculaneum and Pompeii were revealed to the rest of Europe, the demand for Greek- and Roman-inspired neoclassical objects took Europe by storm. Tables and chairs were designed with legs that mimicked Greek and Roman columns, furniture hardware was embellished with laurel wreaths (the symbol of victorious military commanders), and the figures of Olympians became popular motifs. One of the classical relics that captured the imagination of England was a Roman cameo glass vessel from AD 5-25 Alexandria. It had been uncovered in Rome during the Renaissance and later became known as the Portland Vase. Cameo glass is created using an extremely difficult technique: the object is made with two layers of glass, then one layer of glass is cut away to leave a design in relief. Only the most skilled Roman glassmakers ever attempted it, and only fifteen complete Roman cameo objects have ever been found in the Roman ruins. Like the rest of Britain, Josiah was completely captivated by the Portland Vase. It was brought to London, but before it was put on display at the British Museum, he was able to borrow it and carefully study the design. He then attempted to re-create it using the less expensive and more easily reproducible method of pottery. Finally, after four years and thousands of trials, he created an exact replica of the Portland Vase. The replica was made in a substance of Josiah's own invention—a fine-grained stoneware that he called jasperware.

Jasperware would be his greatest technical innovation, and like any great PR person, Josiah made sure everyone knew it. When he put *his* Portland Vase on display in London, he sold tickets and created such a frenzy that people had to be turned away. His marketing acumen and design savvy throughout the course of his life guided him well. At the time of his death, he was worth £600,000 (equivalent to around $100 million today), and jasperware has been in continuous production ever since.

The cauliflower coffee pot (top) made in 1759 showcases Wedgwood's famous green glaze. But it was the Portland Vase (above)—a perfect replica of the one made in Rome between AD 5-25—that gave Wedgwood his celebrity.

JASPERWARE HEADBOARD

designed by **EDDIE ROSS**

For this project, Eddie Ross was inspired by Wedgwood's black jasperware pottery—a type of stoneware invented by Josiah Wedgwood that featured white relief designs on a matte black surface. Wanting to take Wedgwood beyond pottery, Eddie Ross used moldings from the hardware store to create a jasperware headboard. To create a headboard of your own, let your imagination run wild and devise a design using moldings of your choice.

INSTRUCTIONS

1 Using sandpaper, smooth out any rough edges on the door. Paint one side of the door and the edges using the matte finish paint. Let it dry, then flip it over and paint the other side. Spray all the ornamental appliqué pieces, picture frames, and PVC with primer so they are evenly white.

2 Once all the painted pieces are dry, lay the door on a sturdy surface. Using the measuring tape and T-square, decide how you want your picture frames arranged. Mark the placement spots lightly with pencil. Using the caulk gun and Liquid Nails, apply glue all the way around the back side of each frame. Press each frame firmly into place. Gently nail a wire brad into each of the corners of the frames to ensure solid contact with the door. Make sure the nail is flush with surface of the frame. (Use a spare nail or knife blade to remove any Liquid Nails that oozes out from behind the frame.)

3 Play with the placement of each piece of molding within the frames. When you are happy with the placement of each piece, apply Liquid Nails to the back of the molding and glue it in place. Glue additional moldings outside the frames, about 1" (2.5 cm) from the top and the bottom of the headboard. Allow the glue to set for 3 to 4 hours or overnight.

4 To finish off the design, create a border around the entire door by nailing the shorter precut PVC trim strips to the short side of the headboard 3/4" (2 cm) from the headboard edge. Nail the longer trim pieces to the top and bottom of the door. Nail at 2 or 3 spots along the length of the door as well as into the shorter trim pieces. Spray primer on a cotton swab and dab it onto the exposed nail heads. Let the paint dry.

5 Identify where you will hang the headboard. Use the stud finder to locate the wall studs that will be closest to the edge of the headboard. On the left edge, measure 1 1/2" (3.8 cm) down from the intended final height of the headboard, which should cause the bottom of the headboard to sit slightly lower than the mattress, depending on your preference. Nail one of the picture hangers to the wall. Repeat on the right side, making sure the hangers are at the same height so the headboard is level.

6 Locate the spots on the back of the headboard that correspond with the picture hangers on the wall. Screw D-ring hooks into the headboard at these spots, and hang the board.

MATERIALS

1 standard-size interior hollow core door, cut at the store to the width of your bed (ours, for a queen-size bed, is 66" / 168 cm)

Matte finish paint, in black

A variety of ornamental moldings (look for flowers, ovals, and various geometric shapes)

Three 14 x 23" (35.5 x 58.5 cm) ply panel picture frames

Two 12' (3.65 m) pieces of 1 1/2 x 2" (3.8 x 5 cm) white PVC trim, cut at the store into 2 long and 2 short pieces that match the height and width of your headboard (ours were 67 1/4" / 171 cm and 30" / 76 cm long)

Two cans of spray-on shellac-based primer, in white

Package of 1 1/4" x 18 (30 mm x 18) wire brads

2 heavy-duty picture hangers, 100 lb (45 kg) rated

2 large D-ring hooks

TOOLS

220-grit sandpaper

Paintbrush

Drop cloth

Measuring tape

T-square

Pencil

Caulk gun

Liquid Nails

Hammer

Cotton swabs

Stud finder

18th-Century Sweden
GUSTAVIAN STYLE

WHAT MOST OF US KNOW ABOUT SWEDISH DESIGN MIGHT BE SUMMED UP BY A certain large blue-and-yellow big-box store. But the beginnings of Swedish design took root during the reign of King Gustav III in the 18th century, long before IKEA became a furniture mecca.

Young Gustav grew up with a flair for the dramatic. In 1753, when he was only seven years old, his father, King Adolf Fredrik, had a tiny chinoiserie pavilion built in secret and placed on a little hill on the palace grounds. The pavilion was created purely for the amusement of his wife, the queen. On her birthday, Gustav dressed in the costume of a Chinese mandarin, recited a verse, and presented his mother with the key to her new toy. His sense of fun and adventure continued into his early twenties when he traveled incognito through France, playing down his royal lineage and soaking up the culture and fashions as a "normal" person. But in 1771, upon the death of his father, he returned home to assume the Swedish throne at age twenty-five.

The Swedish court had been fascinated with French style since the 17th-century, and when Gustav's parents were married, his mother had added a few pieces of Louis XV–style French furniture to their palace. But after his visit to France, Gustav wanted to incorporate a more neoclassical French look into the palace, which leaned on the symmetrical, straight lines of columns, pilasters, and Greek key patterns. Initially, Gustav invited French furniture makers to Sweden to furnish the palace, but the Swedish treasury was not as well off as he had hoped, so he was unable to pay them. When the furniture makers went home, they left the furniture they had already made, and local craftsmen set to work copying the style, using slightly less ornate details and a palette of light grays, blues, and pale greens—colors that did wonders to amplify light on dark Swedish days. This style became known as Gustavian, and it was the Swedish take on French neoclassical style.

One of the uniquely Swedish takes on the neoclassical style came from the town of Mora, where local farmers built tall Gustavian-style case-clocks to supplement their incomes. The tall wooden cases were all based on the shape of a figure eight, but the style of the case varied depending on the carpenter who made it—some were more curved with floral details and had a strong rococo influence, while clocks with cleaner lines were more neoclassical.

Although influenced by the extravagant salons at Versailles, the resulting Swedish style emphasized restraint—gold and silver were used sparingly, and the overall effect was one of calm serenity rather than over-the-top glamour. The simplicity and sensibility of the Gustavian style has had a lasting influence. In fact, as recently as the late 1990s, that Swedish furniture giant, IKEA, introduced a revival of Gustavian furniture featuring plain wood lacquered in ivory and brightly colored finishes.

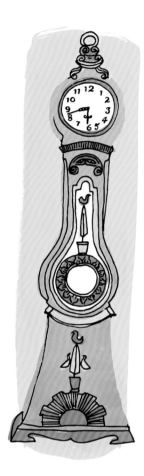
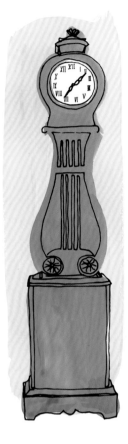

Gustavian Mora clocks were traditionally presented to brides on their wedding day.

Though Gustavian style is loved for being simple yet elegant, Gustav's life tended toward the dramatic. When he was twenty-eight years old, King Gustav started running the royal theater, supervising every aspect of production, from musical scores to the wallpaper in the actors' dressing rooms. He loved costume and organized nonstop *fêtes champêtres*, garden parties where all members of the court were required to appear in costume. Gustav even regulated the daily attire of his court, calling for formal dress during bad weather and informal clothing on sunny days, which he would spend at his mother's Chinese pavilion. The dress code for each day was posted on a card in the king's audience chamber, but he was known to change his mind several times in the course of a day, requiring the court to undergo speedy costume changes at a moment's notice. Ultimately, his love of costume ended his life. In 1792, at the age of forty-six, he organized a masquerade ball at the theater, and the anonymity of the gathering provided the perfect sinister cover for an assassin: Gustav was shot at point-blank range and died two weeks later.

GUSTAVIAN CLOCK

designed by **KATE PRUITT**

When designing this modern, rustic clock, Kate Pruitt wanted to echo the shape and simplicity of the Swedish clocks produced in the town of Mora during the 18th century. We used carbon paper to transfer the design onto the boards, but you can also copy the design onto acetate, project it onto the boards, and paint over the projected design. Salvaged wood was used for this project, but if you want, you can buy new planks at a hardware store and stain them for an aged effect.

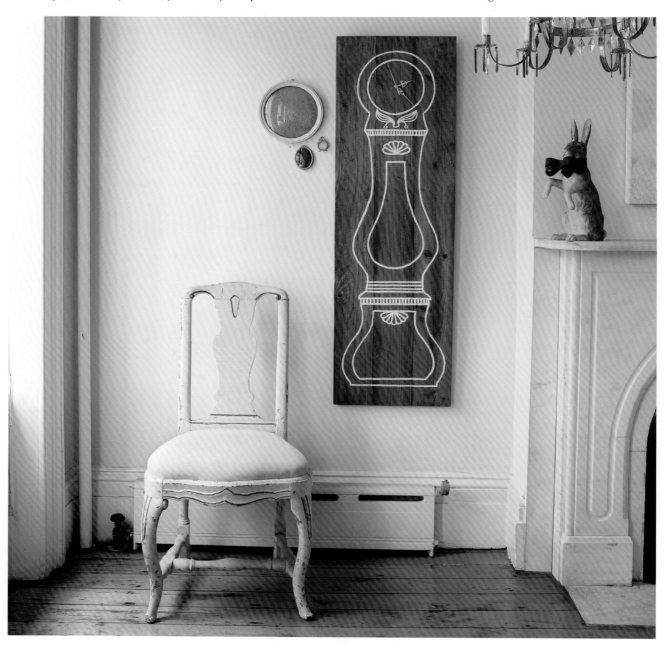

INSTRUCTIONS

1 Clean and lightly sand the boards. Place the planks down on the drop cloth and arrange them, one next to the other, into a tight row of three.

 Open the clamps an inch or two (2.5 to 5 cm) wider than the width of the three boards together (about 18" / 46 cm). Run a line of glue the entire length of the plank edges that will come in contact with one another. Use your finger to spread the glue over the surface of each edge—it's okay if a little drips; you can clean it up later.

2 After applying glue to each edge, reposition the planks exactly as they were, with the "good" sides facing up, forming one giant board. Immediately clamp the planks together at the top, bottom, and middle. Slowly tighten the clamps, which will make the planks squeeze together, then use a damp cloth to wipe up the glue drips from the seams on the top. Let the glue set at least an hour. Then remove the clamps and test the strength of the glue; your board should feel like one solid piece. Turn the board over and use a chisel to gently remove the beads of glue on the back. If you have trouble removing any glue from either side, you can also sand the piece down again.

3 Use the ruler and chalk to mark straight, level edges on both the top and bottom of the board. Use the saw to cut along those lines in order to create even edges. Sand rough edges until they are smooth.

4 The image on page 122 needs to be enlarged at 600% to achieve the correct size—48" tall and 14 1/4" wide (122 x 36 cm). Take the template to your local copy store and ask them to print the full enlargement in black and white on large-format paper.

5 Tape a layer of carbon paper over the full surface of the board, and then tape the copied image directly over it with the image facing up. Trace over the lines firmly with a pencil to transfer a carbon copy outline onto the boards.

6 Lay the board on a flat work surface that you can comfortably stand over. Use your white paint and thin paint brush to carefully paint over your traced outline. A little inconsistency is perfectly acceptable—it will add to the charm of the design. Allow the paint to dry completely.

7 Use a ruler to find the center of the clock face, and mark the center point with a pencil. Drill a hole through the center point. Assemble the clock movement through this hole following the manufacturer's instructions. Attach small eye hooks and picture wire to the back of the board in order to hang it, or simply lean it against a wall as a floor clock.

FINISHED SIZE
17 x 54 x 1"
(43 x 137 x 2.5 cm)

MATERIALS
3 planks of old wood fencing, approximately 3/4" (2 cm) thick x 5' (1.52 m) tall x 5 1/2" (14 cm) wide; choose boards that are straight and have no bowing, curving, or chipped edges

Wood glue

White acrylic paint

Clock movement kit with silver hands for 3/4" (2 cm) deep surface (see Resources, page 142)

Small eye hooks

Picture wire

TOOLS
Sandpaper

Drop cloth or scrap cardboard

Three 24" (61 cm) adjustable metal clamps

Rag

Chisel or paint scraper

Ruler or T-square

Chalk or white colored pencil

Saw (a circular saw is best, but a table saw, jigsaw, or hand saw will work)

Large sheet of carbon paper, to transfer image

Pencil

Small paintbrush

Drill with 5/16" (8 mm) bit

FEDERAL STYLE

FEDERAL STYLE HAS ALWAYS BEEN INTERTWINED WITH THE LOOK OF AMERICAN government. Named after George Washington's political party, it was the predominant style in America after the Revolutionary War. It's no accident that when the Founding Fathers looked for architectural models for the new nation's capital city, and even for their own homes, they were inspired by classical antiquity. After all, if the new country's democracy was to have its roots in classical Greek models, it followed that the style of its buildings and the furnishings within should proclaim that association.

Although Federal style was an adaptation of neoclassical style, certain decorative elements were distinctly American. The eagle, for instance, was adopted as the national symbol in 1782 and quickly became a favorite motif in Federal designs.

While colonists were preoccupied with the Revolutionary War, keeping up with European trends was the last thing on their minds. It was not until after the war, when there was an explosion of new construction, that any kind of "style" found its way into American homes and newly built government buildings. The resulting Federal style was actually an adaptation of several styles, most predominantly neoclassical and Palladian. Inspired by the excavations of ancient Italian ruins, the neoclassical style had already swept through Britain and France, and now, in the late 18th century, it reached the interiors of American homes and public buildings. The buildings themselves were inspired by the work of Renaissance architect Andrea Palladio, who was famous for incorporating ancient Greek and Roman architecture into non-governmental and non-religious buildings (see page 24). The new America embraced both of these Greek- and Roman-inspired styles, but adapted them to fit the needs of the growing country and utilized materials sourced in North America.

The most fastidious of Federal architects would have to be Thomas Jefferson. He was the ultimate gentleman builder, which meant he wasn't paid for his designs but did it as a hobby. In between congressional sessions and presidential duties in Washington, Jefferson's all-consuming passion was his home in Virginia. Over the course of his life, he would spend more than forty years designing, redesigning, building, and rebuilding his home, Monticello. The centerpiece of Monticello was the building's columned portico, a feature that took years to get right. While Jefferson was in Washington, he ordered

the columns to be assembled, and returned to find that they had been installed crooked. Jefferson was the ultimate type-A personality (he even measured his own architectural drawings to the thousandth of an inch), so the crooked columns were unacceptable. He ordered the workers to install them again. Every aspect of the construction at Monticello was treated with the same attention to detail—if it wasn't done right, it would be done again until Jefferson deemed it perfect. All of this building and rebuilding meant that Jefferson lived his entire life in a construction site, yet it wasn't a burden for him. Instead, it was a form of play. He often said that "putting up and pulling down [is] one of my favorite amusements."

During the course of the history of the United States, Federal style has become completely interwoven with the style of government power. A Federal interior was made to feel spacious and light, with polished wood floors, smooth plaster walls, and decorative white moldings. The motif of choice was either the eagle (which became the nation's symbol) or a circle of stars, symbolizing the original thirteen colonies.

FURTHERMORE

Jefferson submitted a design for the White House, but it was rejected by George Washington in favor of the design by Irish architect and Philadelphia resident James Hoban.

●

On a trip to France, Jefferson brought back more than an appreciation for neoclassical style—he also developed a taste for French food, including ice cream. The first recipe for ice cream in America was handwritten by Jefferson and brought back from France.

The image of Monticello appears on the reverse of the nickel. The number of steps depicted on the Palladian-inspired portico is a signifier of value—many collectors hunt for coins that depict five or six steps. The steps, however, were a later addition to Jefferson's home; during his lifetime, the portico was unfinished and visitors entered via a ramp.

Federal style made abundant use of woods sourced in North America, such as rosewood, mahogany, walnut, pine, and birch.

FEDERAL MIRROR

designed by **SHANNA MURRAY**

For this project, Shanna Murray created her own version of the convex mirrors that adorned the walls of many Federal-style homes. The artwork she designed echoes the white molding found in American homes in the 18th century, but has simplified, modern details that will work beautifully in contemporary homes.

INSTRUCTIONS

1 Scan the template on page 123. Enlarge the scanned image by 200% and print onto clear water-slide paper. Allow the printout to dry thoroughly (approximately 30 minutes).

2 In a well-ventilated area, spray the Krylon on the water-slide paper, so it covers all parts of the artwork. Allow the Krylon to set for 30 to 60 minutes, then repeat. You want the sheet to have a sheen (this may require a third coat).

3 Using scissors, cut away the excess paper surrounding the artwork. Fill your bowl with water and completely submerge the water-slide paper. After about a minute, it will start to separate from the paper, but don't let the paper slide off completely.

4 While the decal is still slightly wet, slowly pull the paper away from the decal, then place the decal on the wall, sliding it around until it is exactly where you want it to go. Working from the middle, smooth out any air bubbles with your fingers.

5 Once the decal is in place, attach hanging strips and mount your mirror on the wall inside the decal.

MATERIALS

Clear water-slide printer paper
(see Resources, page 142)

Krylon Acrylic
High Gloss spray

8" (20.5 cm) round,
beveled mirror

Damage-free hanging strips

TOOLS

Scanner

Inkjet printer

Scissors

Wide, shallow bowl

Early 19th-Century France
EMPIRE STYLE

EMPRESS JOSÉPHINE, WIFE TO NAPOLÉON BONAPARTE, LOVED TO THROW PARTIES.
But when it came to entertaining, it was never quite enough to follow the fashion of the moment—she always took the party-planning one step further. She had a particular passion for botanicals, and at one dinner in Paris with 150 guests, she decided to forgo the usual stiff flower arrangements and instead placed fresh green turf along the center of the long tablecloth, bordering it with flowers to create a meadow. Eventually, Joséphine decided she needed a larger canvas for her creative experiments. And so, before Napoléon left for his Egyptian campaign in 1798, the couple toyed with the idea of purchasing a country estate. While house-hunting, Joséphine fell in love with one of the estates they toured. Located eight miles west of Paris, Château de Malmaison covered nearly 150 acres of land, including meadows, a vineyard, an orchard, and woodlands. It also needed extensive renovations. Napoléon was deterred by the high price tag and the list of necessary repairs, but Joséphine was fixated on the house, seeing it as a grand opportunity to play with plants and flowers and entertain on a larger scale. And so, after Napoléon had left for Egypt (and knowing the news would be slow to reach him), she went against his wishes and borrowed money to purchase Malmaison. She justified her choice by imagining that great wealth would come from the Egyptian campaign—but the campaign would turn out to have more impact on art and design than on the coffers of the French government.

When Napoléon returned three years later to discover that Joséphine had

Empress Joséphine had many swans wandering about the garden of Malmaison, and she adopted the swan as one of her favorite decorative motifs. In addition to chairs with swan's-head armrests, Josephine had serving dishes with swan's-head handles, swan tables, and even swan figures as bedposts.

bought the estate, he was initially furious, but he eventually came around and even started to design improvements for the home. He bought an additional five-thousand acres of surrounding land, improved the farm buildings, and hired interior designers Charles Percier and Pierre Fontaine to redecorate the home. Like nearly everyone else in Europe at the end of the 18th century, the Bonapartes and their designers were infatuated with neoclassical style, and the excavations of Herculaneum, Pompeii, and other Etruscan sites were a never-ending source of decor inspiration. And like the ruling kings before him, Napoléon understood the importance of crafting an aesthetic that would assist in legitimizing his claim to power. To that end, his designers created a style that came to be known as Empire, which echoed Napoléon's military campaigns (with salons that resembled army camps and a bounty of Egyptian furnishings, such as sphinx heads and obelisk motifs), but was also a spin on neoclassical style, featuring many actual antiquities from Pompeii and Herculaneum. Additionally, the 165 scholars traveling with Napoléon in Egypt had created immense catalogs full of sketches detailing Egyptian art and design, and many of these motifs found their way into Malmaison.

Joséphine spent her time carefully curating every moment of a visitor's experience at Malmaison. Exotic animals, such as kangaroos, gazelles, and zebras, wandered through the park and gardens, and her black swans imported from Australia became famous throughout Europe. (The swan also became a motif that was carried throughout the design of Malmaison, from a swan bed to swan's-head teacups.) In the garden, Joséphine played the role of a grand collector, filling the beds with tulips imported from Holland and the massive greenhouse with orchids and scented tropical gardenias from the Americas. Her rose garden contained 197 varieties and was the largest in France, and she built a heated orangerie with enough room for 300 pineapple plants. Joséphine looked for any opportunity to entertain outdoors with games on the lawn and theatrical performances held in tents or pavilions, but even indoor entertaining at Malmaison emphasized the estate's natural setting. For the fruit course at elaborate dinners, footmen carried decorative dwarf fruit trees from the orangerie into the dining room so that even in winter, guests could pick their own cherries, plums, and apricots.

When Napoléon divorced Joséphine after fifteen years of marriage—primarily because of her failure to produce children—she stayed on at Malmaison . . . but not in isolation. Her entertaining schedule at the estate was as full as ever, a result of her ability to create the most unique and captivating parties. She died in 1814, at age fifty, in her tented bedroom at Malmaison, surrounded by paintings by the famed floral artist Pierre-Joseph Redouté.

FURTHERMORE

Joséphine imported a Neapolitan chef to work at Malmaison—his sole responsibility was to prepare ice creams, including a raisin and liqueur flavor that came to be known as glace Malmaison.

EMPIRE-INSPIRED PLATES

designed by JULIA ROTHMAN

Illustrator Julia Rothman tapped into Empress Joséphine's love of entertaining to create a set of plates that would be perfect for hors d'oeuvres. (Or you can skip the snacks and use a tray on your dresser to hold your keys, jewelry, or spare change.) Napoléon and Joséphine loved to monogram everything, from the backs of upholstered chairs to glassware and dinnerware, so Julia embellished her monograms with neoclassical motifs that would have pleased the royal couple, such as laurel wreaths and rosettes.

INSTRUCTIONS

1 Photocopy the templates on page 129 at 125%. Using a pencil, trace the letters and design of your choosing onto the tracing paper. Using scissors, cut around the tracing paper design, leaving 1 to 2" (2.5 to 5 cm) around all edges.

2 Tape the tracing-paper designs onto your chosen dish. When you're happy with the composition, cut a piece of transfer paper just large enough to fit beneath the design.

3 Lift one side of the tracing paper and slide the transfer paper underneath. Tape the design back in place.

4 Trace over the design firmly with pencil, then lift both papers from one side to ensure that the design has transferred. Once the design has transferred completely, remove both layers of paper and the tape, then use cotton swabs to remove any loose carbon dust surrounding the design.

5 Pump the paint pen on a piece of scrap paper to produce a strong, even flow of paint. Carefully trace back over each design with the paint pen. To add multiple colors to a design, let the first color dry for at least 5 minutes before going back with the second color.

6 Let the paint dry for 24 hours, then follow the instructions on the paint pens for setting the paint in the oven. The dishes are now washable and ready to use!

MATERIALS
Set of plates or other dishes (We used small square side plates)

Pebeo Porcelaine 150 China Paint Fine Tip Markers, in desired colors (available in art supply stores)

TOOLS
Pencil

1 sheet of tracing paper

Scissors

Transparent tape

1 sheet of carbon transfer paper

Cotton swabs

GOTHIC REVIVAL

THE LEGACY OF THE GOTHIC REVIVAL MOVEMENT CAN BE SEEN EVERY YEAR ON October 31, when the streets are suddenly filled with costumed vampires, were-wolves, demons, dragons, and magicians. It was the genre of Gothic fiction (and its horror film legacy) that first inspired these spooky characters, and it can be traced back to the English author Horace Walpole, and more specifically to his home, Strawberry Hill House, in Twickenham, England.

Horace Walpole, born in 1717, was the son of the first British prime minister, Robert Walpole. He was the youngest son in a fabulously wealthy family at a time when being a gentleman meant one didn't work. As an adult, Horace spent most of his time and energy building a home in Twickenham—a chic village just two hours by carriage from London known for its fashionable summer villas. The architectural style of the moment was decidedly neoclassical, but instead of classical columns and a Greek facade, Walpole wanted something a little more dramatic. And nothing was more dramatic than Gothic architecture.

Gothic Revival style was inspired by medieval churches, but adapted for use in private residences. For instance, at first glance, the fireplace shown here looks more like an entrance to a Gothic cathedral than a place to warm your feet.

The style is usually considered to have begun with the renovation of the Abbey of Saint-Denis in Paris, initiated by Abbot Suger in 1140. The abbot felt that art was central to the religious experience, and the style he incorporated featured pointed arches, ribbed vaults, and arched flying buttresses—all features that became associated with a new style called "Gothic." From the time of the renovation until the 16th century, Gothic became the go-to style for everything intended to inspire awe and grandeur, from churches and castles to bridges and city walls.

While on his grand tour of Europe (see page 46), Walpole had the opportunity to see the great Gothic cathedrals in France, and when he was an undergraduate at Cambridge, he had also been inspired by the Gothic architecture of King's College chapel. And so, even though Gothic architecture was out of vogue, he decided it was just the thing to make his Twickenham home unique. After leasing one of the last remaining sites on the banks of the Thames in the desirable neighborhood, Walpole set about re-creating a Gothic castle where the knights

of Arthur's Round Table would have felt at home. He christened it the Strawberry Hill House, and it became his elaborate plaything.

Every last detail of the house, from the architecture to the furnishings, was a whimsical take on Gothic design. The home was a miniature medieval castle, with dramatic touches, such as a staircase lit by a single lantern, a fireplace based on the designs of medieval tombs, and a grand reception room based on the funeral chapel of Henry VII. Walpole liked to say that the house was made of paper since papier-mâché was used to provide Gothic touches throughout the home (the frieze in the great parlor was papier-mâché, as were the ceiling ornaments in a bedroom). He felt that an elaborately fantastical house inspired by medieval life demanded equally fanciful furnishings, so he assembled an eccentric collection of objects, such as the gilded armor of Francis I, the spur King William wore at the Battle of Boyne, and the jeweled dagger of Henry VIII. The collection consisted of 4,000 items, each object with a more incredible story than the last.

Visitors were welcome to tour the home, entering through a courtyard with its own cloister, along with niches and basins for holy water. Walpole gave personal tours to his more illustrious visitors, but made his housekeeper responsible for the more common guests. During its heyday in the late 18th century, the house was perhaps the most famous in England and was such a tourist attraction that Walpole had to issue tickets to control the flood of visitors (he charged the equivalent of $1.50 for the privilege of stepping inside).

In such a theatrical atmosphere, it's not surprising that one day, Walpole awoke from a dream in which, "On the uppermost banister of a great staircase, I saw a gigantic hand in armour." That one little fragment of a dream inspired him to write *The Castle of Otranto*—the first Gothic novel—which would go on to inspire the works of Bram Stoker, Edgar Allan Poe, and Mary Shelley (which would, in time, inspire those countless Halloween costumes).

FURTHERMORE

The word serendipity *was coined by Sir Horace Walpole. It came from* The Three Princes of Serendip, *a fairy tale published in Venice in 1557.*

The open tracery with quatrefoils carved into the back of this chair has a look taken directly from a medieval church.

GOTHIC HERALDRY PILLOWCASE

designed by DIVA PYARI

The Walpole family shield was heavily incorporated into the decor of the Strawberry Hill House, appearing on several windows and over doorways throughout the home. For this project, designer Diva Pyari of Linea Carta was inspired by Horace Walpole's love of heraldry and wanted to find a way to incorporate a Gothic family crest into a modern home. The designs on these soft pillows are a perfect nod to Gothic decor, but without all the spooky touches.

INSTRUCTIONS

1 From the templates on pages 124, choose the illustration and letters you would like to use on your coat of arms. Photocopy the letters at 100% and the coat of arms illustration at 150% (or at the size you like best for of your pillow).

2 Cut out the shapes from the printouts and glue the letters onto the illustrations to create a personalized design. (Note that the images and letters on the template are reversed, but they will face the right direction once they are ironed onto the fabric.)

3 Photocopy (or scan and print) your personalized design onto a sheet of iron-on transfer paper. Using scissors, cut around the artwork, trimming right up to the edge of the design.

4 Place the transfer paper artwork ink-side down on the pillowcase. Following the instructions on the package, use a hot iron to transfer the illustration to the pillowcase. When the design is cool, peel off the backing paper.

5 Stuff the pillowcase with the pillow form.

MATERIALS
Cotton or linen pillowcase

Iron-on transfer paper for textiles (see Resources, page 142)

Pillow form

TOOLS
Glue stick

Scissors

Iron

VICTORIAN ENGLAND

1837–1901

The clutter and coziness of the Victorian period was not appealing to everyone. William Morris said that he had "never been in any rich man's house which would not have looked better having a bonfire made outside it of nine-tenths of all that it held." That sentiment became the rallying cry of the Arts and Crafts movement, which, in turn, would pave the way for a cleaner design aesthetic in the following decades.

IN OUR FAST-CHANGING MODERN TIMES, IT SEEMS THAT JUST AS WE GET A HANDLE on how to work the latest phone or computer, it's time to adapt to a new one. In the mid-19th century, Britons found themselves in a similar predicament—their world was suddenly gripped by ever-accelerating advancements in technology. By contrast, England of 1800 was primarily made up of small agricultural villages that had remained unchanged for centuries. The furthest a person would typically travel was to the nearest market town, and the fastest thing anyone had ever seen was a galloping horse. When the railways came along, all that changed, and by the 1840s, there were railways connecting small towns all over England. The rapidity of these advancements left Victorians both exhilarated and overwhelmed, but one thing was for sure: Daily life for the English would never be the same.

During this time, technological advancements abounded, from medical marvels (chloroform for surgery, a vaccine for smallpox, and X-ray photography) to transportation solutions (suspension bridges, railways, steamships, buses, trams, subways, automobiles, and bicycles) to accelerated communication (the telegraph, telephone, and typewriter), and all manner of inventions that brought modern comfort and convenience (safety matches, sewing machines, glass bottles with rubber nipples, kerosene lamps and electric lights, and canned and frozen foods). These rapid changes in technology flooded the market with consumer goods. New factories could produce items in bulk, and railways ensured that the products were sent far and wide.

One outcome of all this growth was that quite a few people got rich very fast. Although there was still extreme poverty (as written about in many of Charles Dickens's novels), nearly every segment of the population—from poor to rich—saw some improvement in daily life. During this boom, the middle and upper classes had plenty of money to buy objects of all varieties, and they had plenty of room to stash them (a ten-room home was considered the minimum size for an upper-middle-class family). The preferred décor for these massive homes was both nostalgic and eclectic. Four styles were simultaneously in fashion during this era—Greek, Gothic, rococo, and Renaissance—and all were revivals of earlier historic fashions. It was often difficult to choose just one of these styles, so many people simply incorporated them all; the desired effect was one of romantic clutter.

In order to achieve a perfectly cluttered look, one had to go out and acquire the necessary objects. Thus, a collecting mania swept over Britain in the 19th century. The most desirable items were those that had previously only been available to the rich. Lamps and footstools were popular, but decorative objects—from porcelain figurines, paintings, and books, to taxidermied animals, birdcages, and aquariums—were especially coveted. Factories produced these items in massive numbers to keep up with the demand, and for the first

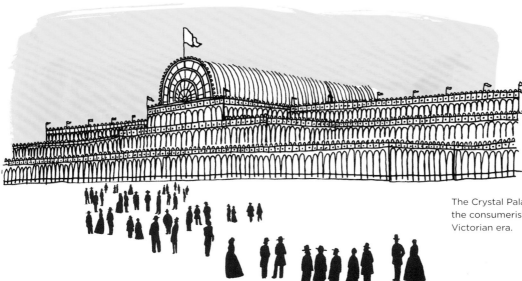

The Crystal Palace was filled with the consumerists wonders of the Victorian era.

time, customers were presented with a range of buying options. For instance, a person could now choose between an inexpensive umbrella or an ornate, costly one.

Although the Victorian style (and the period) is named for a queen, it was actually a prince who was the driving force behind it. In 1840, the twenty-one-year-old Queen Victoria married her German cousin, Prince Albert, and although he was never elevated to the rank of king, he certainly had a kingly appetite for both design and industry. Albert found a way to combine both passions when, along with designer Henry Cole, he conceived a grand exhibition to be held in London that would highlight British industry. Just eighteen months later, the Great Exhibition was held in what came to be known as the Crystal Palace, an iron-and-glass hall built by Joseph Paxton in London's Hyde Park. It covered more than 20 acres (8 hectares), towered more than 100 feet (30.5 m) tall, and was exactly 1,851 feet (564.2 m) long, in celebration of the year. Most impressive, the entire structure was built in only eight months.

The Crystal Palace contained more than 13,000 eclectic items (such as a knife with 1,851 blades, an American Colt revolver, and the Hope Diamond), technological marvels (such as a bed that became a life raft), and massive displays of machinery (such as a hydraulic press). Nowhere else in the world could one view such a sheer mass of stuff. More than six million visitors turned out to see the show in the short six months it was open. Not only did the exhibition make a profit, but it was also a boon to London's already prosperous economy. For months, every hotel and boarding house was full, and every available vehicle was used as a cab to transport visitors. It didn't take long for other cities to follow suit and hold exhibitions of their own, and between 1851 and 1900, nearly 100 were organized in major cities around the world.

CARDBOARD VICTORIAN CANDLESTICK

designed by **DAVID STARK**

For this project, David Stark channeled the ultimate Victorian gentleman, Sherlock Holmes (a lighted candle on the table was the final clue to solving the mystery in *The Valley of Fear*). A candlestick is just one of the many objects that would have been in a Victorian home, and the type represented here was called a chamberstick. A precursor to the flashlight, a chamberstick was used to light one's path while walking at night, though our version is clearly more for looks than for illumination.

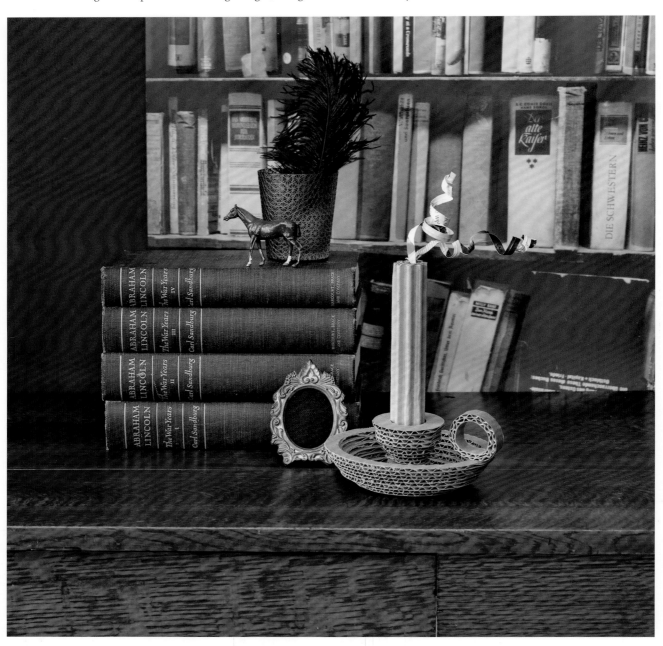

INSTRUCTIONS

1 For the base, photocopy templates A–H on page 126 at 125%, then use the compass cutter to cut out one circle in each of the sizes from the corrugated cardboard.

2 Using the glue gun, attach the smallest base circle A to circle B, making sure that the corrugation lines face the same direction. Continue gluing pieces together, working from smallest to largest, until all the base pieces have been assembled.

3 For the candlestick holder, use the compass cutter to cut circles in the following sizes from corrugated cardboard:

four 1 3/4" (4.5 cm)	four 1 1/2" (3.8 cm)	two 1 1/4" (3.2 cm)	two 2 1/4" (5.7 cm)	one 2 1/4" (5.7 cm) w/ 1 1/4" (3.2 cm) hole	one 2 1/2" (5.7 cm) w/ 1 1/4" (3.2 cm) hole

4 Using the glue gun, attach the circles cut out in step 3 to one another in the order they are listed. Insert the skewer through the centers to keep them aligned, and leave the skewer sticking up out of the base. Glue the candlestick holder to the base using the skewer to align the two parts.

5 For the ring on the side, use scissors to cut one 3/4 x 9" (2 x 23 cm) strip of corrugated paper and a slightly longer strip of kraft paper. Form the corrugated paper strip into a circle; use hot glue to close the circle. Hot glue the kraft paper around the ring, overlapping the ends, and hot-glue the completed ring to the side of the candle base.

6 For the candle, use scissors to cut a 7 1/4 x 6 1/2" (18.4 x 16.5 cm) piece of the corrugated paper (the lines of the corrugation should follow the longer dimension). Roll it up with the corrugated side facing out and seal the inside edges with hot glue to keep the roll tight.

7 Insert the candle into the base so that the skewer is running up its center and the base is resting inside the holder. (The part of the skewer protruding from the candle's top will be its wick.)

8 To form the smoke, using scissors, cut two strips of magazine or newspaper about 12" long and 5/8" wide (30.5 x 1.6 cm). Coat the face of each strip with hot glue. Lay a piece of floral wire on top of each strip and fold the paper in half over the wire, smoothing it down. Repeat with the remaining strip. Curl the strips around a pencil and snip the wires off one end of each strip—on the other end of each strip, leave 3/4" (2 cm) of wire, and use scissors to trim the paper so that it tapers to a point where the wire emerges. Attach the smoke to the candle by inserting the wires into the top of the candle. Carefully apply a touch of hot glue to hold them in place.

MATERIALS

Corrugated cardboard (a small moving box, approximately 22 x 12 x 14" / 56 x 31 x 36 cm would be plenty)

One 10" (25 cm) bamboo skewer

Single-ply corrugated paper, about 9" (23 cm) square, or cardboard with one layer carefully peeled off

Kraft paper

1 sheet of newspaper or magazine paper

Fine-gauge floral wire (26-gauge or similar)

TOOLS

Compass cutter

Hot glue gun with glue stick

Scissors

Pencil

TIP

When cutting the large circles, it can be challenging to keep the compass cutter's point from making a large central hole, which can result in an imperfect circle. To avoid this, affix a nickel-size button to the center of the circle with double-stick carpet tape, which will keep the compass point from moving.

SHAKER DESIGN IN THE UNITED STATES

WHAT DO A SWIVEL OFFICE CHAIR, WRINKLE-RESISTANT FABRIC, AND A CIRCULAR saw have in common? They were all inventions that came from the Shaker community—a Christian group that emigrated to America from England in 1774. This religious communal society believed their homes were the closest thing to heaven on earth, and they worked hard to ensure their living spaces were orderly, efficient, and clean. Many characteristics of the modern home that we enjoy today—such as an appreciation for airy, open space, and sensitivity to balance, proportion, and function—result from the Shaker way of life.

The Shakers were a dissenting, charismatic branch of the Quakers, and were named for their fervent religious dancing (in fact, they were originally referred to as the Shaking Quakers). Upon their arrival in America, they set up a community near Albany, New York, and within fifty years, the initial band of eight individuals had grown to nineteen communities throughout the United States, with more than 5,000 Shaker men and women (or brothers and sisters, as they called one another). No one, however, was *born* a Shaker. The members of the community were celibate, but they frequently took in orphans (who were free to stay or leave once they reached adulthood), and they also recruited outsiders. Living apart from the outside world, Shaker communities shared their resources with one another and were almost completely self-sufficient. Converted craftsmen who were trained in the outside world were especially helpful in shaping the Shaker aesthetic, since they brought with them modern skills and tastes, as well as new techniques and trends.

The Shakers believed in complete gender equality, which was unusual for their time, and the first Shaker leader, known as Mother Ann, brought a strong female presence to the community. In order for the Shakers to maintain their celibate lifestyle, they lived in duplex-style homes with separate entrances (even separate gates) for men and women. Unlike most American towns, where individual homes are spread out to provide privacy, Shaker villages were compact, with important communal buildings—such as the meeting house, dwelling house, barns, and often an infirmary building—arranged close together.

There was no decoration in Shaker rooms; instead, pegs and pegboards, which were used for hanging clothing, hats, mirrors, and even chairs, lined the walls.

Inside the dwelling house, rooms were arranged like dormitories with two to five individuals in each room. With so many people living together in one space, organization and utility were extremely important. At a time when closets and built-in storage were virtually nonexistent in most American homes, Shakers installed floor-to-ceiling cupboards throughout their dwellings. Cabinets and drawers were frequently numbered, and written logs detailed the contents of each compartment. Peg rails—strips of wood hung about six feet above the floor and outfitted with movable pegs—lined the walls of nearly every Shaker room and were used not only for holding clothing and hats, but also for hanging up chairs, small mirrors, and even clocks.

Natural light and cleanliness were two important features of Shaker dwellings. Huge exterior windows and transoms (windows above doorways) were built into all Shaker buildings, and many homes had skylights. But these window treatments were more than cosmetic enhancements—fires were prevented by decreasing the need for additional candles or lanterns, and transom windows (as well as baseboards drilled with holes) helped circulate air throughout the buildings, which the Shakers believed was essential for good health.

Shaker furniture was based on the neoclassical style, which was popular in 18th-century America, but they simplified it to suit their lifestyle. In 1784, the Shaker leader Joseph Meacham declared that Shaker buildings should be devoid of decoration and extravagance. Following this dogma, architectural elements, such as door and window frames, chimneys, stairways, and hardware, were all created with clean lines in basic forms, and there were no beads, tassels, or moldings in sight. Shaker craftsmen might choose to make furniture using beautiful woods, such as birch or chestnut, but they would leave it simple and undecorated.

By the mid-19th century, the orderly style of Shaker design stood in stark contrast to the popular cluttered Victorian look, but as Americans grew tired of Victorian excess, the simplicity of Shaker style gained wider appeal. After the American Civil War, however, the country shifted to a more industrial and urban society, making it more difficult for the community to find new converts. Today, the last remaining Shaker community is located near New Gloucester, Maine, and as of 2009, had three surviving members.

Unlike the Amish, the Shakers embraced new technologies. The community in Pleasant Hill, Kentucky, built horse-powered washing machines to reduce their workload. Today, the Pleasant Hill Shaker community is a National Historic Landmark.

SHAKER HANGING LAMP

designed by **BBBCRAFT**

For this hanging lamp, the sisters of bbbcraft were inspired by the Shakers' belief in simple, functional design. To create this shade, they removed the fabric from an old lampshade and wrapped muslin and twine around its armatures. Not only is the resulting lampshade beautifully unfussy, but it is also a great way to use simple materials to create a practical household item.

INSTRUCTIONS

1 Using scissors, cut or tear off any fabric or paper covering the metal armature of the lampshade.

2 Wrap strips of torn muslin tightly around the armature, covering all metal. Tie off each strip tightly with an overhand knot and cut the end.

3 Using the twine, tie a double knot around one of the vertical spines at the top of the shade, and leave a tail (about 4" / 10 cm) to sew in later. Keeping the twine very taut, begin wrapping it around the entire circumference of the armature, wrapping it around each vertical spine as you make your way around the lampshade. Continue wrapping until you reach the bottom. If you'd like, you can make knots in the twine intermittently for texture. Tie the twine in a double knot and cut it, leaving the end long (at least 4" / 10 cm) to sew in later.

4 Using a sewing needle, sew in the ends along the vertical, muslin-wrapped spines.

5 Wire the light using a lamp kit, such as IKEA's Hemma. Screw in a filament lightbulb and plug in the light to make sure it works before hanging. Hang the lamp from screw hooks in the ceiling.

MATERIALS

Lampshade

Muslin, about 1/2 yard (.5 m), torn into 1/2" (13 mm) strips

Crochet cotton or twine

Lamp kit, such as IKEA's Hemma

40- or 60-watt filament lightbulb

Ceiling screw hooks for hanging

TOOLS

Scissors

Wide-eyed sewing needle

NATIVE AMERICAN TRADE BLANKETS

IN 2009, THE OREGON-BASED COMPANY PENDLETON WOOLEN MILLS HAD THEIR hundredth anniversary as a Native American trade blanket manufacturer. One of the ways they celebrated their anniversary was by collaborating with fashion-forward design house and retail outlet Opening Ceremony to create a collection featuring Pendleton's classic Native American trade blanket patterns. The vibrant designs appeared on everything from handbags and jackets to jumpers and miniskirts, and were featured in fashion magazines from *Elle* to *Vogue*. The fact that these designs are still popular would probably have come as a surprise to the original blanket traders, but the rich colors and geometric patterns have maintained a widespread and long-lasting appeal.

The first blankets created specifically for trade with Native Americans were designed and manufactured by Europeans and the British in the 17th and 18th centuries. Of particular interest to European traders were the beaver pelts and other animal hides that the Native Americans on the East Coast hunted and sewed together to create warm robes. In exchange for these furs, the traders offered small trinkets, steel ax heads, guns, and the first blankets used for trade—Hudson Bay blankets—which were typically pure white wool with black, yellow, red, and green stripes. Hudson Bay blankets were originally manufactured in England and then shipped to a major fur-trading post in Ontario, Canada. The colorful blankets were prized by the Native American population, and traders were equally pleased with the beaver pelts they received in exchange. The arrangement, however, was uneven; for example, the blankets and small items for trade might be worth £650, but the furs could be worth as much as £19,000.

Over time, the look of the blankets evolved as other woolen mills entered into the trade blanket market and began trading with Native Americans all over the country. The striped Hudson Bay blanket was eventually joined by blankets that utilized designs, colors, and motifs popular with native tribes in other parts of the country. Occasionally these trade blankets are referred to as Navajo blankets and with good reason: The Navajo were excellent weavers, and many of the factory-made trade blankets tried to mimic their designs.

The Southwest tribes, particularly the Navajo and the Pueblo, have a strong history of weaving traditions that can be documented back to the 18th century, and their blankets and rugs were particularly prized by tribes throughout North America for their craftsmanship and beauty. They were so warm and water-resistant that even soldiers and ranchers sought Navajo-made blankets, and in 1850, a single blanket might be sold to a non-native for a considerable sum (in the neighborhood of fifty dollars in gold).

Not long after 1850, however, the nomadic lifestyle of the Navajo (and other herding tribes) became a threat to American expansionist interests. After three years of fighting for their land, the Navajo were imprisoned at Fort Sumner in

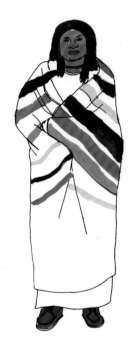

The first blankets used for trading with Native Americans were Hudson Bay blankets, which featured trademark black, yellow, red, and green stripes.

New Mexico, where the government embarked on a failed four-year-long, $1.5 million experiment to turn the Navajo into farmers. Finally, in 1868, the U.S. government gave up, allowing the Navajo to return to a small portion of their tribal lands in northwestern New Mexico and northeastern Arizona. In their reduced territory, the Navajo resumed weaving, and the traders who purchased the blankets from them began to market them as rugs for non-native homes. Soon enough, the Navajo looms were so busy producing rugs for sale that they didn't have time to make rugs or blankets for their own everyday use, and so the traders, in turn, sold factory-made blankets back to them.

In order to give the blankets the most authentic Navajo look and feel, the manufacturers often traded factory-made blankets for the fibers and looms the natives used to make their rugs. But the blankets woven at the factory were softer than the ones handmade by the natives and were also appealing to a non-native audience. Sensing a golden opportunity, dozens of American woolen mills began producing blankets in this style; the most well-known of these is the Pendleton Woolen Mills.

By 1890, almost all of the Native American population in the United States had been moved to reservations, and they were more reliant than ever on the blankets the traders brought to them from mills. When the United States entered World War II in 1942, all wool was rationed for military uniforms, and woolen blanket manufacturing came to a halt. Pendleton was the only company that survived the war and resumed Native American blanket production in 1947. Even today, Pendleton Woolen Mills, which is one of the oldest surviving Native American blanket manufacturers, sells half of its production to Native Americans.

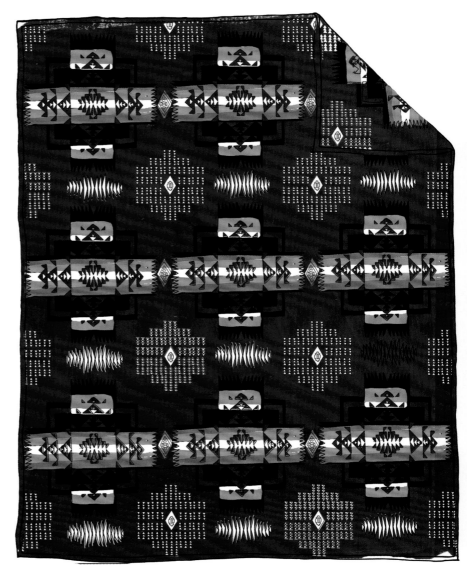

The designs in Native American blankets are not narrative. The blankets were designed by non-native people and were meant to be appealing on the basis of color and pattern, not substance and story.

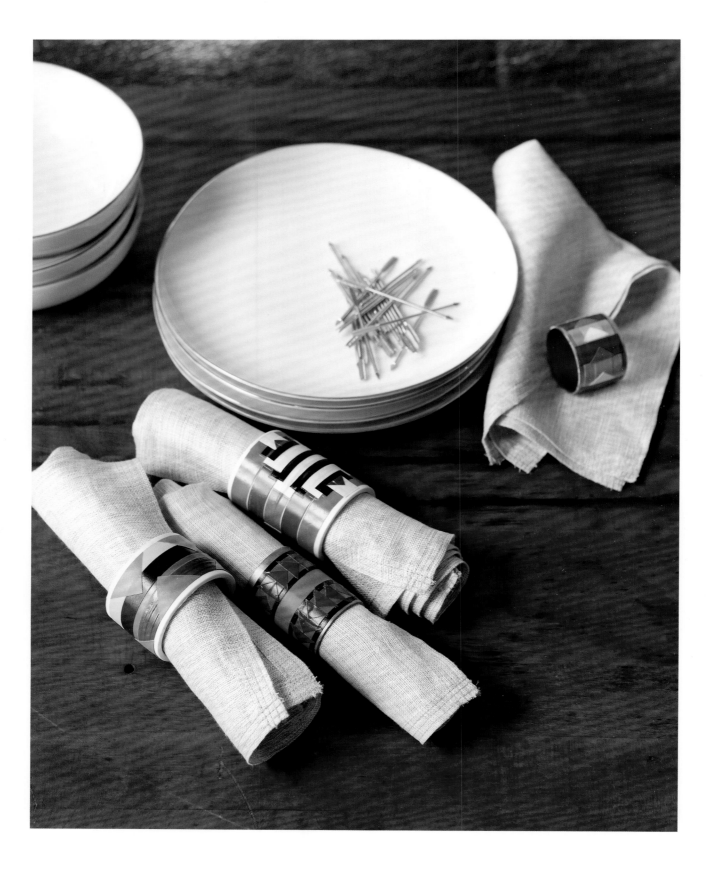

NATIVE AMERICAN NAPKIN RINGS

designed by **CAITLIN MOCIUN**

For this simple napkin ring project, Caitlin Mociun was inspired by the strong colors and geometric designs of Native American trade blankets. To create the napkin rings, she cut out shapes from brightly colored electrical and masking tape and arranged them in artful designs on PVC coupling.

INSTRUCTIONS

1 Clean your couplings in the sink with warm soapy water to remove any dirt, stickers, or residue.

2 Make patterns with tape on the coupling. You can do this freehand by wrapping bands of tape around the coupling and adding smaller triangular and square pieces over the top. You can also measure your coupling and plot your design on paper first. The easiest shapes to cut with the tape are long strips, squares, rectangles, and triangles. If you don't like your design, it's easy to remove the tape from the coupling and start over.

3 When you finish creating the design on the coupling, firmly press down on all of the tape edges. In a well-ventilated area, place the napkin rings on newspaper and evenly spray on a thin coat of clear acrylic. Let dry for 1 or 2 hours, and then repeat two more times.

MATERIALS

4 pieces of PVC or copper coupling, approximately 1 1/2 to 2" (4 to 5 cm) long, and 1 1/2 to 2" (4 to 5 cm) diameter

Brightly colored electrical and masking tapes in various widths

Clear acrylic spray coating (found at art stores)

TOOLS

Dish soap

Scissors

Newspaper

WILLIAM MORRIS AND THE ARTS AND CRAFTS MOVEMENT

IN 1851, THE MOST SPECTACULAR EVENT OF THE YEAR IN ALL OF BRITAIN WAS THE Great Exhibition in London (see page 78). This international exhibition was organized by Prince Albert to showcase Britain's leading role in the industrial revolution, and the 13,000 exhibits ranged from technological marvels to trinkets. The exhibition was visited by six million people—roughly one-third of the entire population of Britain—but not everyone was pleased. The exhibition completely dismayed a young William Morris and his friends. They felt that the mass-produced objects on display lacked soul, and they were disturbed by the polluted air of industrialized London, the heaps of garbage and coal on the streets, and the unhealthy conditions in which the impoverished factory workers labored.

William Morris was born in Essex in 1834, and as the eldest son of a wealthy businessman, he had a privileged childhood spent reading Sir Walter Scott and exploring nature on his pony, sometime dressed in full armor. By the time he was an adult, the industrial revolution was in full swing, and it had completely transformed the physical landscape of England and the culture of its people.

To create his intricate textiles, William Morris researched traditional dyeing methods in old French and English technical manuals and dyed his silk and woolen yarns using natural substances.

Railways and factories crisscrossed the once verdant, open land, and innovations like the telegraph rapidly accelerated the pace of daily life. In response to the changing times, Morris decided to dedicate his efforts (and his talents) to social reforms through art. In 1861, he joined a group of artists and reformers who vocally objected to living in a dehumanizing, mechanized world, and instead committed themselves to an alternative: a world that emphasized the importance of handcrafted objects.

Morris first developed a love for the handmade while he was attending Oxford University, where he began to draw, paint, and design. He was most influenced by the Pre-Raphaelites (as in before Raphael, the Renaissance artist), a group of artists in London who were interested in the medieval period. Morris was particularly interested in the work of Pre-Raphaelite founding member Dante Gabriel Rossetti. Together with a group of friends that included Rossetti, he worked on the tempera decorations of the walls and roof of the Oxford Union Society debating hall.

While working on the hall, Morris met Jane Burden, who was an artist's model and Rossetti's muse. Born in Oxford to a stableman, Jane had

been destined for domestic service until she was discovered by Rossetti. Morris became obsessed with Jane, and once, while attempting to capture her likeness, he showed her the canvas, on the back of which he had written, "I can not paint you, but I love you."

Morris married Jane in 1859, and in anticipation of her rise in social status, Jane learned French and Italian and became an accomplished pianist— essentially re-creating herself.

Morris built a home for his new family in southeast London and named it the Red House for its red brick exterior (exposed red brick without stucco was a novelty at the time). Morris used the house as a place to experiment with traditional techniques and simple decoration. The walls of the whitewashed rooms were decorated with painted glass, embroidered textiles, frescos, and furniture decorated with minutely detailed paintings.

In factory-obsessed London, it was nearly impossible to find furnishings and textiles that were handmade according to Morris's exacting standards. Recognizing a gap in the market, Morris set up an artist collective in London (which would later evolve into his design firm, Morris and Co.) to create the sort of handmade goods he sought for his own home. Many of the products emphasized the revival of forgotten techniques, such as tapestry weaving, and dyeing silk and woolen yarns with indigo and cochineal. Morris became especially well known for his wallpaper patterns, which were made using a traditional inking process instead of machines. To create the wallpapers, the designs were hand-carved into wooden blocks, which were then inked and pressed onto the papers. Each color had to be printed separately.

Morris was a true workaholic, and he believed that nothing should be designed in his studio that he would not want to buy or that he could not make himself. Although Morris was interested in good design for all, the handmade nature of the work (coupled with Morris's belief in compensating his employees fairly) made his designs affordable only to the extremely wealthy— a fact that he found frustrating. He became so much in demand as an interior designer that he raised his fees in an attempt to protect his time, thereby creating an even larger gap between those who could afford his work and the part of society he had originally set out to help.

For someone who prized and idealized domestic happiness, his own was relatively short-lived. Morris left the Red House after only five years in order to be closer to the Morris & Co. headquarters. Shortly after the move, Jane began a long affair with his best friend, the couple's original matchmaker, Dante Gabriel Rossetti. The affair lasted off and on until Rossetti's death in 1882. Jane and Morris remained married, but the affair caused him to throw himself into his work more than ever, and when he died at the age of sixty-two, his doctor identified the cause of death as "simply being William Morris."

This William Morris chair was made using ebonized wood and a woolen tapestry. The original spawned countless imitations throughout England and the United States.

FURTHERMORE

"There is no excuse for doing anything which is not strikingly beautiful." —William Morris

•

The educational transformation of William Morris's wife, Jane Burden, was so striking that she was nicknamed "Queenly" and is thought to have been the model for Eliza Doolittle in George Bernard Shaw's play Pygmalion.

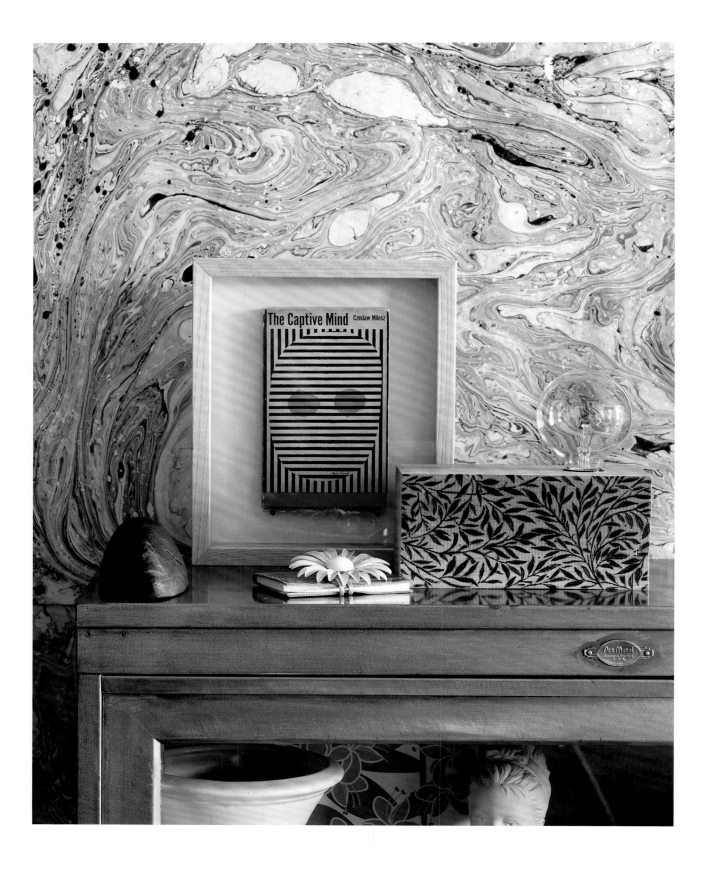

The Captive Mind Czesław Miłosz

ARTS AND CRAFTS WOODBLOCK LAMP

designed by MEG MATEO ILASCO

The wood-burned pattern featured in this lamp design was inspired by William Morris's love for botanical patterns. During the Arts and Crafts movement, William Morris and his company were famous for their botanical designs, which appeared on everything from wallpaper to embroidered fabric. The wood-burning technique that Meg Mateo Ilasco utilized in this project is known as pyrography, which means "writing with fire." The walnut block used for the lamp base is a little nod to the William Morris technique of printing wallpaper designs with carved woodblocks.

INSTRUCTIONS

1 Sand all surfaces of your woodblock and wipe it with a tack cloth. Select which side will be the front of the base and which will be the top where you'll place the bulb. Place the keyless light socket on the area where you would like to put the lightbulb—it should be equidistant from the long edges of the woodblock. Using a pencil, trace a circle around the socket and mark the center of the hole.

2 With a ruler, measure the height of your socket (including the "hickey," which holds the wires at the bottom) and add about 1/2" (13 mm) to that measurement. This will be the depth of the light socket hole. Measure the width of your socket and add 1/8" (3 mm)—this will be the girth of your hole. Place the ruler at the tip of the spade drill bit; measure the depth of the socket hole on the bit and wrap the masking tape around the shaft of the drill bit at this point.

3 Clamp the wood to a stable surface. With your electric drill and the spade bit, drill a hole at the marked spot until it reaches the tape mark on the shaft. Remove all wood shavings. Make sure your light socket fits the hole.

4 Next you'll make a smaller hole for the lamp cord to come out the back of the block. With the woodblock's back facing you, place your ruler on top of the socket hole so that the ruler's edge is aligned with the center of the hole. Draw a line from the hole to the edge of the block closest to you. Place your ruler vertically along the back side and continue this line from the top edge to the bottom edge of the block. Using the socket depth measurement, measure from the top edge of the woodblock and mark the depth of the socket on the line. Using a 1/2" (13 mm) drill bit, drill a hole above the mark until the bit reaches the socket hole. Remove the clamp from the woodblock; remove all wood shavings and wipe the block clean.

5 Photocopy the pattern on page 94 at 100%. With your scissors, trim around the pattern, leaving a 1/2" (13 mm) border. Cut a piece of transfer paper to roughly the dimensions of the patterned paper. Place the transfer paper smooth-side up beneath your photocopied design, and securely tape both papers to the front of the woodblock. Trace the pattern, applying enough pressure to transfer the graphite onto the wood. Remove the pattern and graphite paper.

(see Resources, page 142)

MATERIALS

4 x 4 x 8" (10 x 10 x 20.5 cm) walnut woodblock (you can have a block cut to these dimensions at your hardware store)

Keyless lightbulb socket (see Resources, page 142)

Lamp cord with switch and plug attachment

Spray-on clear coat

Clear lightbulb

TOOLS

60- to 150-grit sandpaper

Tack cloth

Pencil

Ruler

Spade drill bit (slightly wider than diameter of light socket)

1/2" (13 mm) masking tape

Large clamp

Electric drill

1/2" (13 mm) drill bit

Scissors

Graphite transfer paper

Wood-burning tool kit with a selection of interchangeable tips, including a fine-point tip (see Resources, page 142)

Damp cloth

Phillips-head screwdriver

Hot glue gun with glue stick

photocopy
at 100%

6 On a work surface in a well-ventilated area, turn on your wood-burning tool. Practice on a piece of scrap wood to get comfortable with the tool before trying it on your lamp base. Using a fine-point tip, press into the wood to outline the entire pattern. Use the larger chisel-shaped tips to burn larger areas. Use a damp cloth to wipe the tip of your wood-burning tool as you use it, being careful not to let the tip touch your skin. If your tool tip becomes loose, use a pair of pliers to tighten it. If you make any mistakes, sand the marks to remove or dull them.

 Apply a spray-on clear coat to protect the finished design from stains and dust.

7 Use a Phillips-head screwdriver to loosen the two terminal screws on the bottom of the socket. Insert the end of the lamp cord with exposed copper wires through the small hole at the back of the wood block. Feed it through until you can pull it up through the socket hole. Feed the exposed wires through the hickey on the bottom of the socket. Take each set of exposed copper wires and twist it clockwise around a screw (the "hot" smooth wire should go around the brass screw, while the neutral wire will go around the silver screw). Make sure the copper wire is wrapped tightly just beneath each screw head. Tighten the screws.

8 Screw the lightbulb into the socket and plug the cord into an outlet to test it. Once you know the lamp works, sparingly apply hot glue around the socket, then quickly tug on the cord to pull the socket into the lamp base.

SIGNS OF ART NOUVEAU ARE, QUITE LITERALLY, STILL PRESENT IN THE CITY OF Paris. Every day, thousands of people duck beneath the swirling art nouveau Metro entrance at the Porte Dauphine station or the reconstructed stations at Abbesses or Châtelet to reach the mass-transit below the city.

The Paris Metro signs were constructed out of interchangeable, prefabricated cast-iron and glass parts. Designer Hector Guimard created two styles of signs—with and without glass roofs.

Paris was a latecomer to the mass transit shift in the world's major cities. Work on the London Underground began in 1860, and New York City had elevated, steam-powered trains by 1871. But as late as 1890, Paris still did not have a mass-transit system other than horse-pulled double-decker omnibuses, which clogged the city streets. Finally, as plans for the 1900 Paris World Exposition reached a fever pitch, it was decided that Paris should move into the 20th century with a world-class Metro system.

After charming the railway company's president with his fantastical art nouveau designs, Hector Guimard was given the task of announcing the underground system to the world above. His Metro entrance designs were a complete rejection of any historical or classical styles. The posts were made to look like

The scrolling design of Guimard's Metro rail is inspired by plant tendrils, and contains the whiplash curves favored by art nouveau designers.

organic, sinuous stalks rising from the ground, which then bowed under the weight of amber glass lamps made to look like huge tropical flowers. Although the Metro entrances were inspired by nature, the materials used for their construction—mass-produced cast-iron and glass—were a completely modern merging of art and technology, moving France into the 20th century. The first trains ran just in time to carry tourists around the city for the Paris Exposition of 1900.

The art nouveau movement was an effort to create a completely new, modern style. It was named after a Parisian gallery—Maison de l'Art Nouveau—which was opened by the art dealer Siegfried Bing in 1895. The gallery quickly became the gathering place for both creators and devotees of the emerging style. Highly influenced by Japanese design, the style was best known for its twisting asymmetrical lines and organic forms, an aesthetic that was developed in response to the hard metal shapes created by machinery in the industrial revolution. Modern artists, nostalgic for the past, looked to nature for inspiration, and reimagined it in this new, modern style. Although it had a global influence, art nouveau was primarily a European style and became the popular look for everything from high-end furniture to advertisements and magazine covers. Even the most utilitarian object could not escape an art nouveau beautification; hairpins might be adorned with decorative butterfly wings, or the handles of a tea set might artfully mimic the stalks of a fennel plant.

At the Paris Exposition, art nouveau was heralded as the new, completely modern international style. But the lifespan of French art nouveau was cut short by World War I, after barely twenty years. With the advent of war, art nouveau designs seemed frivolous and expensive to produce. The style was replaced by a streamlined modernism that seemed more appropriate for the sober times.

FURTHERMORE

Though the art nouveau style has never come back completely, it is still occasionally resurrected in fashion. As recently as Fall/Winter 2012/2013, art nouveau was inspiration for everyone from Gucci in Milan to Nicole Farhi in London, as shown through the use of iridescent yellows and greens, as well as orchid patterns and sinewy lines in their clothing collections.

BRANCH AND CRYSTAL CHANDELIER

designed by **THE WILD UNKNOWN**

For this project, Kim Krans of The Wild Unknown took her cue from art nouveau designers who saw the organic shapes of plants as the most beautiful of all motifs. This chandelier is made almost entirely of branches, and for a touch of sparkle, it is adorned with antique chandelier crystals. Any type of tree branches will work for this project, though live branches, such as cherry blossoms or pine boughs, are beautiful choices for special occasions (they will dry over time, but will still be beautiful).

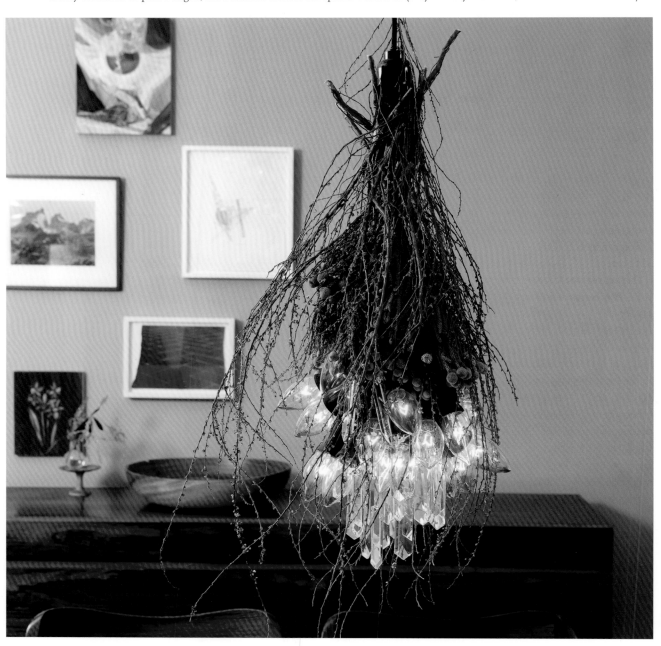

INSTRUCTIONS

1. If you wish to paint your light cord black, carefully remove the bulbs and set them aside. In a well-ventilated area, place the cord on newspaper and spray-paint it black. A light coating will do—try not to get paint inside the vacant sockets. When the paint is dry, replace the bulbs.

2. In your left hand, hold the male end of the string-light cord just below the plug. Let the cord dangle about 6" (15 cm), and with your right hand, bring the cord back up to the left hand, creating a loop. Repeat this action until the cord and lights form an upside-down "bouquet" shape, ideally with all the bulbs at the bottom and the plain cord making the "stem."

3. Wrap the stem several times with wire. Cinch the loops tight using a twisting motion with the needle-nose pliers. Continue to wrap the stem with wire until the form feels sturdy. Note that it is important to use plenty of wire; don't worry about how it looks—the wire will be hidden by branches and foliage.

4. Attach the black extension cord to the male end of the lights. Secure the connection between the two cords by making a crisscrossing X shape with wire around them where they meet. Tighten by twisting the wire with needle-nose pliers to ensure a strong connection.

5. At this point, it is best to hang your chandelier while you continue to work on it. If you have the spot ready, hang it up by installing a hook, and finish the chandelier in place. If not, find a support you can hang it from, such as a shower curtain rod, and make sure to loop the extension cord around the rod twice to prevent slipping.

6. Cut a 5 to 6" (12 to 15 cm) length of wire for each of your crystals. Thread the wire through the hole in the crystal, twist the wire around itself a few times to ensure it will hold, and bend the other end into a hook shape. Hang the crystals from the bottom of the "bouquet" of lights. You can adjust the placement later, hanging them very close to the lights or cascading downward. If possible, use the needle-nose pliers to wrap and twist the hooks around the cords, securing the crystals in place.

7. One stem at a time, place foliage around the "stem" area of the bouquet and attach it by wrapping it with wire. Use the branches and foliage to hide as much of the cords and the wire as you would like, as well as the extension cord connection.

8. Keep adding crystals, branches, and foliage until you like the overall shape and visual effect of your chandelier.

FINISHED SIZE
Approximately 16 x 16 x 24"
(41 x 41 x 61 cm), plus
additional cord

MATERIALS
String lights, with
approximately 20
tear-shaped bulbs

Black matte spray paint
(optional)

Gardening wire or other
flexible wire

Black extension cord,
approximately 28' (8.5 m) long

Hooks, for hanging

Various new or antique
chandelier crystals
(with holes for hanging)

Foliage and branches

TOOLS
Newspaper

Small wire cutters

Needle-nose pliers

WIENER WERKSTÄTTE

ALTHOUGH NOT ONE OF THE BETTER-KNOWN DESIGN MOVEMENTS, THE WIENER Werkstätte—a design collective based in Vienna in the early 20th century—went on to influence an international spectrum of artists and designers, such as the German Bauhaus, French art deco, and midcentury Scandinavian design. With its stylistic emphasis on clean lines and geometric shapes and a heavy reliance on black-and-white color schemes, the Wiener Werkstätte heralded the arrival of a new modernism. The Wiener Werkstätte (which translates to "Vienna Workshops") was founded in 1903 by Koloman Moser and Josef Hoffmann. Both men had been founding members of the Vienna Secession, a progressive group of artists and designers that included Gustav Klimt. When they were in their early thirties, Moser and Hoffmann parted ways with the Vienna Secession due to aesthetic differences and decided to start their own collective, where they would have control over the artistic vision.

At the turn of the century, Vienna was one of the leading cultural centers in Europe. Vienna had a rising intellectual middle class with a hefty appetite for luxury, making it the perfect center for avant-garde designers. The modernist battle cry was "less is more," but for the Wiener Werkstätte, "less" didn't mean less luxurious. Though the designs were often simple, the collective utilized lush materials like rare woods, mother-of-pearl, and semiprecious stones. With the financial backing of banker Fritz Wärndorfer, the Wiener Werkstätte expanded from three small rooms to a three-story building with separate spaces for metalwork, leatherwork, bookbinding, woodworking, and painting.

The aesthetic of the collective was further refined when Hoffmann was introduced to the works of Scottish designer Charles Rennie Mackintosh, whose geometric designs were in stark contrast to the sweeping curves and floral motifs of the French art nouveau. Wärndorfer, who had a personal interest in design, had hired Mackintosh to create the music room of his Viennese villa, and once Hoffmann saw the room, it had a huge impact on his future work. From that point on, geometric shapes became the hallmark of the Wiener Werkstätte's designs—rectangles with an open center, circles, and squares were used on everything from ceramics and cutlery to furniture and lighting. (The square was used so frequently in Wiener Werkstätte designs that it was often referred to as the "Hoffmann Square.")

Designed for a sanatorium near Vienna, this chair features open-centered rectangles as well as Josef Hoffmann's favorite geometric shape: the square.

The collective aimed to promote the cultivation of good taste—whether that applied to small, everyday objects like utensils or locks, or to the overall architectural design of a building, everything was worthy of being designed with good taste. The first big commission for the Wiener Werkstätte came in 1904 when they were asked to design a sanatorium in Purkesdorf, near Vienna. The sanatorium specialized in treating "nervous complaints," so the collective designed clean, bright rooms to create a calming effect and left the rooms sparse. The furniture designed for the space had smooth, easy-to-clean surfaces without decorative trims.

Shortly after designing the sanatorium, Hoffmann brought in the largest project for the collective, and what would be his personal crowning achievement: the Palais Stoclet in Brussels. It was the collective's opportunity to exercise their belief in *Gesamtkunstwerk* (total artwork)—an environment in which everything was designed down to the smallest detail. The geometric exterior of the house was entirely clad in white Norwegian marble with gold-leaf trim. Inside the house, every item was thoughtfully designed, from elaborate artwork and light fixtures to flatware, silver toiletry containers, and kitchen tools. The centerpiece of the home was the dining room, where Gustav Klimt created a frieze depicting the tree of life, an exotic dancer, and a pair of entwined lovers, all made from white marble plaques that were inlaid with mosaics. Hoffmann designed the equally lavish furniture and tableware: a dining table with twenty-four matching chairs covered in reindeer hide, long sideboards made from black marble and Macassar wood, silver flatware, serving dishes, and wineglasses.

At the height of the Wiener Werkstätte's success, more than 100 different artisans worked for the collective, catering largely to the tastes of the Jewish upper-middle class in Vienna (though there were sales outlets in Karlsbad, Berlin, Zürich, and New York City). The organization only approved objects of outstanding quality and beauty, and their motto was "Better to work 10 days on one product than to manufacture 10 products in one day." The brand developed a reputation for their high-quality designs, and anything labeled "WW" was guaranteed to be an excellent product. Although hugely important to their artistic relevance, this attention to quality meant that they were never able to produce a large enough quantity of work to sustain the organization financially. In 1914, Wärndorfer, their financial director and benefactor, left the workshop under pressure from his family (who wanted to prevent his complete financial ruin); he emigrated to the United States and became a farmer. And then, with the Stock Market Crash of 1929 and the rise of the Nazi party in 1930, the collective disbanded. The city of Vienna was devastated during the Nazi regime. In 1938, there were 181,882 Jewish people in Austria, almost all of them in Vienna, and by 1942, Austria was home to between 2,000 and 5,000 Jews; the rest had lost their fortunes and emigrated or lost their lives under Nazi rule.

When it came to design at the Wiener Werkstätte, it wasn't always all about the square. In this case, the hammered fruit bowl demonstrates an even more important modernist conceit: "Form follows function." A square wouldn't make sense for a fruit basket.

FURTHERMORE

Iconic 1920s fashion designer Paul Poiret was so inspired by the work of the Wiener Werkstätte that in 1912, he opened his Atelier Martine, an interior design school for girls from working-class backgrounds.

•

Hoffmann's designs are still being produced and used in homes around the world. In 2000, the Italian design firm Alessi reissued Hoffmann's Rundes Modell cutlery set, which had been originally made by hand in silver. Hoffmann's Kubus Armchair design from 1910 is also still in production.

CAST METAL SWITCHPLATE

designed by **COLLEEN & ERIC WHITELEY**

For this project, Colleen and Eric Whiteley were inspired by the Wiener Werkstätte's use of precious metals and geometric designs. They used real molten metal for this switchplate, but this metal is nontoxic (bismuth is what gave the Bismol in Pepto-Bismol its name), easy to use, and casts beautifully. (It can also be melted down again and again, so if you're not happy with your first pour, you can always re-melt your metal and try again!) Colleen and Eric used toothpicks to create the design for the mold, but you can experiment with any materials you like, such as coins, string, or other household items that will leave an interesting impression.

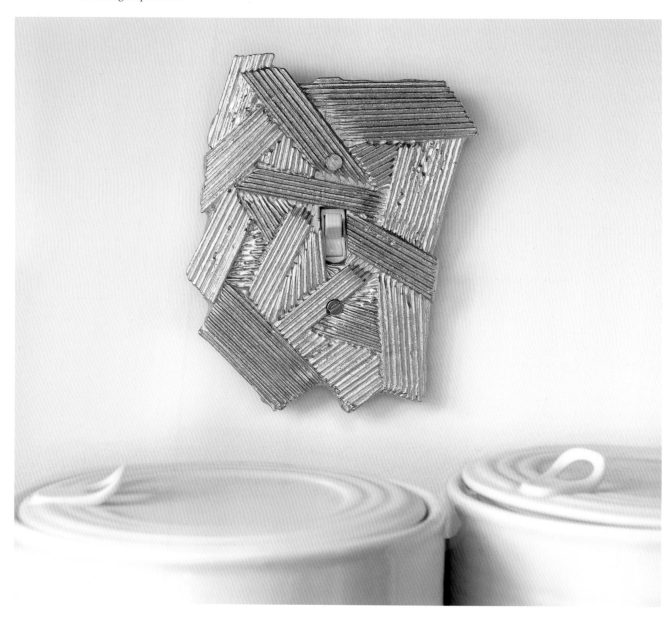

INSTRUCTIONS

1. Apply toothpicks with hot glue to the face of the switchplate. Glue the toothpicks individually or in groups to build up a three-dimensional sculpture. The toothpicks can hang off the outside edges, but leave the cutout clear for the switch to pass through. The metal cast you will make in the next step will be identical to this design.

2. Cover a flat, smooth surface with plastic wrap or wax paper and follow the package directions for mixing the mold-making putty (be sure to wet your hands to prevent sticking). Once mixed, the material feels like clay. Form the putty into a rough rectangle a little larger than your switchplate collage and about 1/2" (13 mm) thick.

3. Carefully lay the switchplate on the putty with the collage facing down. Press firmly to ensure the putty captures all the details. It should come up around all the edges, forming the sides of your mold—these edges will prevent any metal from leaking out when you pour it into the mold. Let the mold set for 2 hours, then carefully extract your switchplate collage.

4. In a clean work area, set up your mold on a flat, level surface. Before you start heating up your metal, put on safety glasses, heat resistant gloves, a long-sleeve shirt, pants, and closed-toe shoes.

5. Place the metal in an old pot and melt it over medium heat. Once the metal turns to liquid, heat it for 2 additional minutes. Bismuth will melt at exactly 281°F (138°C), but you want it to be a little hotter so it stays liquid until you're done with your casting.

6. Working quickly but safely, pour the metal into the mold. Let the mold sit for at least 3 hours; the metal must solidify and be cool to the touch.

7. Once the metal has cooled, remove the cast from the mold. Using the original plate as a guide, line up the window and drill the holes for the screws using a 5/32" (4 mm) drill bit. (You can also use a countersink drill bit so the screws will sit flush.)

8. Lay the original plate on top of a piece of felt and trace around the shape with a pencil, then draw another rectangle 1/4" (6 mm) inside of it. Use scissors to cut along both outlines, leaving you with a rectangle with the center cut out. Apply double-sided tape to the felt and stick it to the back of your switchplate. This will help your plate sit tightly against the wall. Screw the switchplate onto the wall.

MATERIALS

Plastic switchplate

1 lb. (455 g) of bismuth/tin alloy, with a 281°F (138°C) melting point (see Resources, page 142)

Small piece of felt for backing

TOOLS

A box of toothpicks

Hot glue gun with glue stick

Easy Mold Silicone Putty or Resilpom II (see Resources, page 142)

Plastic wrap or wax paper to cover work surface

Safety glasses

Heat-resistant gloves

Old cooking pot with a strong handle

Drill and 5/32" (4 mm) drill bit

Countersink drill bit (optional)

Pencil

Scissors

Double-sided tape

THE BAUHAUS

Designed by Bauhaus teacher Marcel Breuer, the frame of the Wassily chair was inspired by bicycle handlebars.

DESIGN WITHIN REACH IS A POPULAR HIGH-END STORE THAT SELLS ICONIC midcentury furniture and designs, but if the Bauhaus period had never existed, DWR would have virtually nothing in their shops. The Bauhaus was a small art and design school that operated in Germany between the world wars and it had a profound impact on the development of midcentury modern design, producing some of the most famous and well-loved artists, furniture designers, and architects of the 20th century.

The Bauhaus school was founded in Weimar, Germany, in 1919 by the architect Walter Gropius. Much like the medieval relationship between master and craftsman, each student signed an apprenticeship contract upon entering the school. The teachers at the Bauhaus included some of the most exceptional artists of the time, such as Paul Klee, Wassily Kandinsky, and the architect Mies van der Rohe, and the curriculum was radically different from other art schools, focusing on the concept of "total design." To that end, the workshops were designed to obliterate the division between fine arts and crafts, stressing the links between architecture, painting, and crafts such as glass decoration, pottery, metalwork, carpentry, printmaking, and bookbinding. The workshops had a dual goal: Students not only learned the principle of "total art," but they also created goods that were sold in order to support the school. Gropius encouraged the students to create designs that consisted of only a few simple parts so they could be easily adapted to industrial production. As a result, some of the most iconic mass-produced midcentury designs were first handmade at the Bauhaus, including the Wassily chair, which was designed by Bauhaus instructor Marcel Breuer. Inspired by bicycle handlebars, Breuer created a simple chair frame using bent tubular steel and used canvas to create the arms, back, and seat. Although the chair was intended for mass-production, the prototype was hand-assembled using nuts and bolts; later, it was mass-produced by Knoll International.

Although the Bauhaus had a forward-thinking take on art and education, they perpetuated the unfortunate tradition of unequal gender roles, barring women from taking certain classes like painting, architecture, and wood carving. Women were pushed instead toward more home-centric crafts like weav-

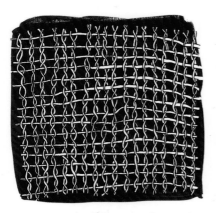

Anni Albers was famous for experimenting with open weaving. One of her exhibits at the Museum of Modern Art in New York featured woven room dividers with varying degrees of opacity.

ing and bookbinding. When twenty-three-year-old Anni Fleischmann wasn't allowed to take a glass workshop (led by her future husband, Josef Albers), she settled for a weaving course. Anni threw herself into the program, and working with textiles quickly became more than just a second choice. With her fine art background, weaving became the perfect outlet for experimenting with color, pattern, and texture, and she was determined to do with textiles what fine art painters such as Klee and Kandinsky were doing on canvas. She went on to became one of the most famous textile artists of the 20th century and is today considered a pioneer of modernism.

Because the school embraced both mass-production and traditional arts and crafts, the Bauhaus became the place where the ideals of the modernist aesthetic were formed. But the Nazis shut down the Bauhaus in 1933. Two of the most gifted Bauhaus weavers, Otti Berger and Friedl Dicker, were among the twenty or more teachers and students who were executed in concentration camps. Before Dicker died in Auschwitz, she spent time at the Terezin camp, where she taught drawing and art to children.

The teachers and students who escaped the Holocaust dispersed throughout Europe and America, and the philosophy behind the style expanded throughout the world, having a huge international impact on architectural and design trends. Walter Gropius and Marcel Breuer went on to teach at the Harvard School of Design, which produced such well-known architects as I. M. Pei and Philip Johnson. Josef Albers became the head of the Department of Design at Yale University, and he and his wife, Anni Albers, went on to become significant artists, teaching at Black Mountain College in North Carolina. During their tenure at Black Mountain College, American avant-garde dancer Merce Cunningham formed his influential dance troupe, and the American composer John Cage performed the first "happening," a mostly improvised musical performance. As a result of the Bauhaus teachers and artists scattered around the world, the modern art philosophy seeped into other art forms, revolutionizing the language of art and design.

FURTHERMORE

A Bauhaus-style building will typically feature glass curtain walls, cubic blocks, and unsupported corners.

•

The word Bauhaus *means "architecture house" in German.*

Ludwig Mies van der Rohe's Barcelona chair was designed for the German Pavilion at the 1929 International Exposition in Barcelona, Spain. The chair was inspired by military campaign chairs and is still manufactured by Knoll.

BAUHAUS SHOWER CURTAIN

designed by NIGHTWOOD

The design for this macramé shower curtain was inspired by the open, airy weaving of Bauhaus textile artist Anni Albers, who studied weaving at the Bauhaus school and became well known internationally for her use of color, pattern, and texture. While Anni worked on a loom to create her textile weavings, design studio Nightwood mimicked her style using a clothesline, broom, and macramé.

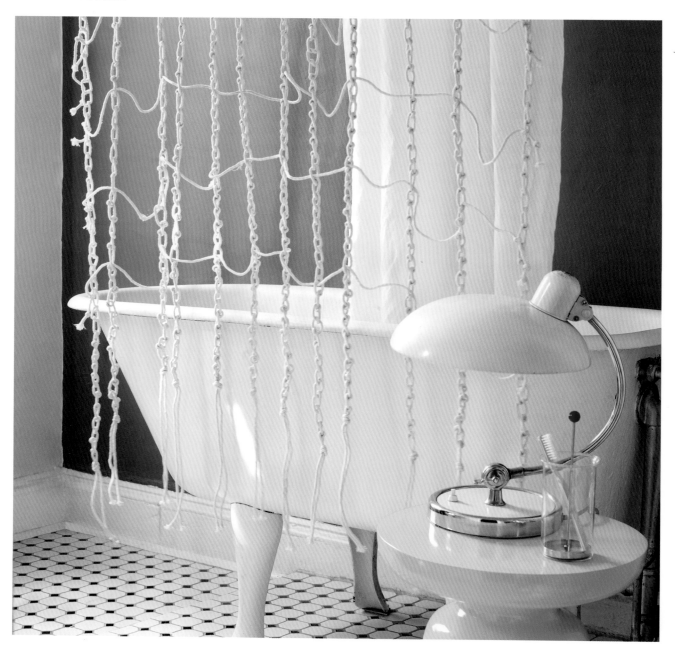

INSTRUCTIONS

1 Cut twelve 25' (7.6 mm) pieces of clothesline, and nine 8' (2.4 m) pieces of clothesline.

2 Secure one long piece of cord to the broomstick. To do this, make a loop of cord at its midpoint and pass it over the top of the broomstick and then back under the broomstick. Then, make a larkshead knot by passing the ends of the cord through the loop and pulling gently to snug the knot down, leaving about 1" (2.5 cm) of space. Tie a regular overhand knot at the top of the cord, 1" (2.5 cm) under the bar.

3 Your knot on the broom should have two strands of cord hanging from it. To work the macramé, hold one cord in each hand. Place the right-hand cord over the left-hand cord. Lift the bottom cord up, over, and through the loop formed by the top cord. Pull the loop, but leave about 1" (2.5 cm) of space between each knot. Now place the left-hand cord over the right-hand cord and through the loop formed by the top cord. Pull the loop, leaving 1" (2.5 cm) of space between each knot. Repeat these two steps until you have a 6' (1.8 m) length of macramé. Tie a knot at the end and leave the edges hanging.

4 Continue creating macramé cords with the remaining long strands.

5 When you have made all 12 macramé cords, attach them together. Take one of the short pieces of clothesline and attach it to your first macramé cord, two knots down from the top, by looping the cord through the open space of the second knot and tying an overhand knot. String the free end of the cord through the second macramé piece, again through the second loop from the top. Make sure that the two macramé pieces are 6" (15 cm) apart and tie an overhand knot. Continue to weave and tie off the cord through the remaining macramé strands, keeping each macramé strand 6" (15 cm) apart, until all twelve macramé segments are attached. As you tie knots, make sure not to pull too tight or leave them too loose; you want the cord to move in a straight line through all the loops. Leave about 4" (10 cm) at the end of the cord and tie it off with a knot.

6 Repeat the process of tying the macramé strands together using another cord. Count ten knots down from the first cord you tied, insert another cord through this loop, and tie a knot. Continue tying knots across the remaining eleven macrame cords, ten knots down from the previous row, leaving 6" (15 cm) between each macramé cord. Continue to attach the cords this way until they have all been used.

7 Slide your curtain off the broomstick, loosen your larkshead knots, and hook it onto your shower curtain rings over the curtain liner. Trim the ends of the cords for a cleaner look, if desired.

FINISHED MEASUREMENTS
To cover a 5 x 6' (1.5 x 1.8 m) shower curtain

MATERIALS
Eight 50' (15.2 m)-long packages of clothesline

Shower curtain liner

TOOLS
Scissors

Broomstick, for tying macramé

FURTHERMORE

When Scott and Zelda Fitzgerald received a $50,000 bonus, their dream purchases included a Picasso etching, a white satin day-dress for Zelda, and two first-class tickets to Europe on a luxury liner.

BORN DURING THE HEIGHT OF THE ROARING '20S, THE STREAMLINED ART DECO style permeated everything imaginable, from toasters and jewelry to skyscrapers and movie palaces. This wasn't a movement with a social or political manifesto—art deco was a style of decorating that threw off the curves of art nouveau, embraced the geometry of the Cubist movement, and was inspired by the symbolism of the ancient Aztecs. Art deco designers in the thick of the "Machine Age" frequently used aluminum and stainless steel for their materials, though lacquer, Bakelite, and inlaid wood also played starring roles.

The style came into being in 1925 at the International Exposition of Modern Industrial and Decorative Art in Paris. The exposition had been in the planning stages since before World War I, and the works on display were all original. It was an opportunity for France to flex its artistic muscle and assert its role as arbiter of fashion and good taste. Although not coined until the late 1960s, the term art deco is derived from this exposition. There were two versions of the art deco style—a more streamlined modern look that became extremely popular in the United States and a fluid French style that reflected a more subdued version of art nouveau.

After World War I, Europeans and Americans alike became captivated by anything that went fast—whether it was ocean liners, planes, cars, or even radio waves. Before World War I, aside from the extremely wealthy and adventurous who traveled on epic ships like the *Lusitania* and the ill-fated *Titanic*, the majority of ocean travelers to cross the Atlantic had been immigrants. But when the U.S. government tightened the reins on immigration, ocean liner companies scrambled for new business. In the heady days of the 1920s, they found their untapped market: newly wealthy Americans who were attracted to European glamour and were generally looking for a good time. With Prohibition restricting alcohol on the mainland, the best time to be had was found on a luxury ocean liner; once the ship was twelve nautical miles out to sea, champagne flowed for the entire voyage.

The enormous Lalique chandeliers in the grand salon of the *Normandie* were the epitome of luxury and French art deco design.

To attract this new wealthy clientele, most of the ocean liners were made over, and the modern style of art deco, with its clean lines and elegant details, was the perfect look for the updated ships. Each ocean liner company competed with the others to put the fastest, most extravagant boats in the water, but the ships produced by the French Line were the epitome of luxury and elegance. The most glamorous of the fleet was the SS *Ile de France*; commissioned in 1927, it was the first of the new liners to be decorated in the art deco style, and its earliest celebrity passengers included Greta Garbo, Ernest Hemingway, and Errol Flynn (Flynn was famous for wearing a tuxedo and red socks during his entire voyage and subsisting on a diet of caviar and Champagne).

This was the era when twenty pieces of luggage were considered the minimum for survival on an ocean liner. (After all, the trip would last eight or nine days and a guest would be expected to change clothes four times a day.) When

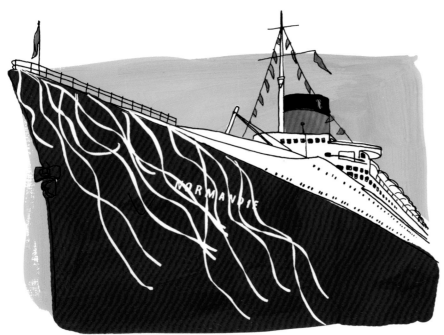

First-class cabins on the *Normandie* had multiple rooms and came equipped with pianos and private decks.

Josephine Baker boarded the *Ile de France*, she received special permission to drive onto the quay in her Bugatti before retreating to her deluxe suite, accompanied by a maid, several dogs, a cat, and at least sixty trunks.

In the 1930s, the French Line had competition from German and British companies who were also producing ships with modern designs. In 1935, the French Line countered with their flagship, *Normandie*, the most ambitious vessel they had ever created. The ship was a monument to the two tenets of art deco style—luxury and speed. Once aboard the *Normandie*, passengers could entertain themselves in a 75-foot-long (23 m) swimming pool or in the 380-seat cinema, and in the first-class smoking room, they could read the daily newspaper printed by the *Normandie*'s own onboard print shop. But the heart of the *Normandie* was the grand salon, the ship's centerpiece of art deco style. The room was lit by two enormous Lalique crystal chandeliers, each weighing five tons, and a dozen fountains were set in rows between the tables. The walls were decorated with murals depicting the history of navigation, and above the captain's table loomed a sculpture of a woman in Grecian costume holding a bucket filled with caviar.

Much like the art deco movement itself, the Normandie became a casualty of war. By the late 1930s, the style had started to lose its appeal. Mass-produced art deco goods saturated the market, making the style feel less special, and the austerity of World War II made art deco seem like a gaudy luxury. While docked at the New York harbor, following the German invasion of France, the *Normandie* was seized by the United States under right of angary (an international law that can be called upon in times of war) with the intention of turning it into a warship. It caught fire in 1942 while welders were transforming it for the war. The ship burned for four hours and then sank at the Passenger Ship Terminal on Manhattan's West Side. Many of the beautiful interior objects were rescued and sold at auction.

ART DECO MOBILE (OR PIÑATA)

designed by **CONFETTISYSTEM**

Inspired by the glamour of steamship travel, Julie and Nicholas of CONFETTISYSTEM created a glittering mobile that echoes the dramatic art deco chandeliers aboard the *Normandie*. For more festive gatherings, the mobile can easily be turned into a piñata. If you fill it with streamers and confetti, it will pay homage to the celebrations that always erupted when the ship left the harbor.

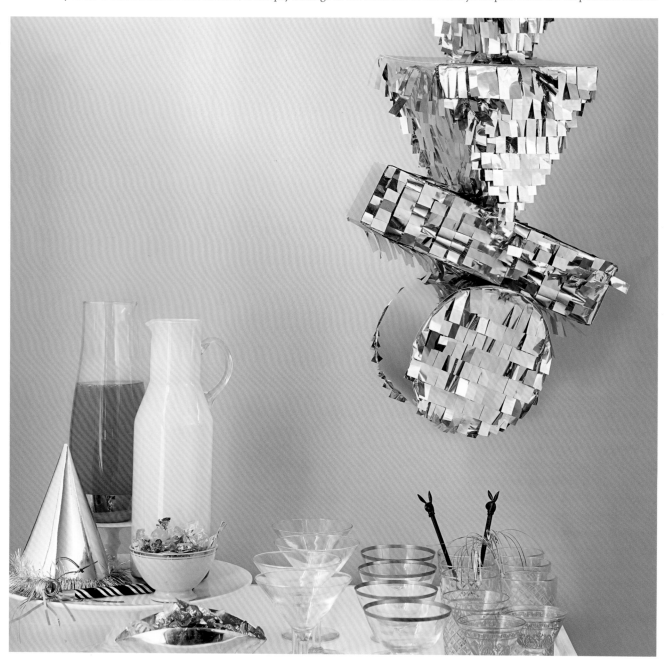

INSTRUCTIONS

1 The mobile/piñata shown here is made from three different three-dimensional shapes—a circle, triangle, and rectangle—which are then attached to one another. Decide on the shapes you want to include in your project. Using a pencil and ruler, draw the shapes onto cardboard using the following dimensions, then cut out each with a ruler and utility knife:
 - Small triangle: Cut out two 5" (12.5 cm) triangles (all sides are the same length), and three 4 x 5" (10 x 12.5 cm) rectangles (for triangle walls).
 - Large triangle: Cut out two 8" (20.5 cm) triangles (all sides are the same length), and three 6 x 8" (15 x 20.5 cm) rectangles (for triangle walls).
 - Circle: Cut out two 7" (18 cm) diameter circles, and one 4 x 22" (10 x 56 cm) rectangle (for circle wall).
 - Rectangle: Cut out four 3 x 12" (7.5 x 30.5 cm) rectangles, and two 3" (7.5 cm) squares (for rectangle walls).

2 Use masking tape to assemble the shapes. For each shape, leave one wall unattached.

3 On a flat surface, arrange the shapes in a line, open-side up, in the order they will be hung. Use an awl to poke holes in the center of the top and bottom of each shape. Thread the string through the holes, and leave extra string at the top for hanging. Make a large knot at the bottom end of the string and secure it with tape to the outside of the shape, making sure it is sturdy.

4 If making a piñata, fill each shape with candy and confetti.

5 Attach the remaining sides to each of the shapes using masking tape.

6 Cut the Mylar sheets into 2" (5 cm) strips and use scissors to fringe one long edge of each strip.

7 Start with the bottom shape, sliding the other shapes away on the string so there is room to work on all sides. Apply glue with a brush to the piece and attach the fringe in rows, folding the short edges of Mylar over about 1/2" (13 mm). Be sure to avoid getting glue on the string. Apply fringe only to the walls of the shape (except for circles), trimming excess fringe; leave the tops of the triangles, sides of circles, and ends of rectangles unfringed. Continue adding fringe until all of the shapes have been decorated.

8 Cut pieces of gold paper, following the dimensions above, to cover the tops of the triangles, sides of circles, and ends of rectangles, cutting a slit in the paper to accommodate the string at the top of the shape.

9 Once the glue is dry, slide the shapes down on the string and hang the mobile/piñata from a ceiling hook.

MATERIALS
Cardboard

Masking tape

Nylon string

Confetti, streamers, and candy
(if making piñata)

Ten 18 x 30" (46 x 76 cm)
gold Mylar sheets

One 18 x 24" (46 x 61 cm)
sheet of gold metallic paper

Ceiling hook, for hanging

TOOLS
Ruler

Pencil

Utility knife

Awl

Scissors

White glue

Paint brush

1930s America
HOLLYWOOD REGENCY

AFTER THE GREAT DEPRESSION AND THE AUSTERITY OF WORLD WAR I, AMERICANS in the 1930s increasingly looked to Hollywood as a means of escape. And Hollywood responded, not only with movie stars and extravagant costumes, but with elegant sets bedecked in satin, velvet, and gold brocade.

But it wasn't just the movie sets that were fabulous—the real-life homes of the newly rich movie stars were also glitzy and glamorous, and the style came to be known as Hollywood Regency. The look was a light, fresh, and sophisticated take on the Regency period of early 19th-century England. The original Regency style was relatively formal, with strong, classical references to Greek and Egyptian design, such as sphinxes, busts, and classical columns. In typical dramatic Hollywood fashion, designers took the original style a step further, showcasing bright colors (such as turquoise, salmon pink, emerald green, and saffron), mirrored furniture, and luxurious textiles, all on a grand scale.

As the film industry exploded in Los Angeles, so did the frenzy around it. Movie stars were expected to represent a glamour-filled version of the American dream, both on and off the silver screen, and many of them turned to interior designers to help meet this expectation. One of the most famous Hollywood Regency decorators was former silent-movie star Billy Haines. Billy had a successful career as an actor, but when he refused to deny rumors of homosexuality, he was released from his contract with MGM. He had dabbled in antiques, so transitioning into a second career as an interior decorator was a natural fit. His big break came in 1933 when he decorated the Brentwood home of his celebrity friend Joan Crawford. She freely admitted to having bad taste (she had a collection of 2,000 dolls and possessed several black velvet paintings of dancing girls), and so she was game to let Billy transform her home. For the decor, he chose sparkling chandeliers and upholstered whole rooms with large swaths of white satin and fringe. When Joan entertained, her guests were often impressed by the striking decor, and as a direct result, many of them became Billy's clients. He designed the homes of leading Hollywood stars and film producers such as Gloria Swanson, Carole Lombard, Marion Davies, and George Cukor, and continued designing until the 1970s, even working on Ronald and Nancy Reagan's home when Reagan was the governor of California.

For all its associations with the silver screen, the Hollywood Regency style wasn't confined to Hollywood. By the 1940s, the look had also infiltrated the homes of East Coast blue bloods and many famous hotels. Society maven Dorothy Draper was one of those responsible for bringing the glamour of Hollywood to East Coast hotels. Dorothy was born into luxury in Tuxedo Park, just north of Manhattan, one of the first gated communities in America. (It was built by Emily Post's father and had the added distinction of being the birthplace of the men's tuxedo.) Dorothy had a natural aptitude for decorating and designed her homes with such style that friends frequently asked for her assistance. After a

FURTHERMORE

Designer Dorothy Draper turned the cafeteria-style restaurant at The Metropolitan Museum of Art into one of the most glamorous restaurants in Manhattan, with a central pool that was filled with sculptures and theatrical birdcage chandeliers.

rocky divorce, Dorothy threw herself into decorating as a career. Her big break came when she was asked to redo apartment buildings in New York City that were owned by the Phipps family. Dorothy had the exterior of each building painted black and added a shiny white trim. She then had each door painted a different color, choosing vibrant shades of green, red, yellow, blue, and bright purple. Before the renovation, the Phipps family had struggled to find renters at a mere $50 a month; after the renovation, the units were quickly rented for $180 each.

Dorothy's trademark was her use of bright, bold colors and oversize patterns. The look was perfect for spaces that needed to make a statement, such as hotel lobbies, clubs, restaurants, and retail stores. She became known for her use of stark contrast, frequently using black-and-white stripes against fanciful neobaroque-style plasterwork and huge expanses of mirrors. By the late 1940s, she wrote for several newspapers and magazines and had become a national celebrity.

The Hollywood Regency style fell out of favor in the 1950s and '60s, but reemerged in 1990 when David Geffen purchased the Billy Haines–decorated home of Jack Warner (of Warner Bros Studios). Geffen sold all of the furniture that came with the estate, and young designers across the country became fascinated by the glamorous relics that emerged. The style was quickly adopted

Dinner at Eight, starring Jean Harlow, epitomized Hollywood glamour in the 1930s. The movie was filmed in black and white, but the set designers used eleven shades of white to convey high style.

by designers looking to make a big statement. In 2000, Hollywood designer Kelly Wearstler (who cites Dorothy Draper as an influence) used a playfully exaggerated take on the Hollywood Regency style for the decoration of the Avalon Hotel in Beverly Hills and the Viceroy Hotel in Santa Monica. Jonathan Adler is another designer who finds ways to translate the Hollywood Regency style into fun, dazzling pieces that work for the modern home, such as tufted gray velvet sofas and shiny lacquered cabinets. The success of modern designers carrying on the Hollywood Regency tradition is proof that there is always a market for glamour.

HOLLYWOOD HANG-IT-ALL

designed by ASHLEY MEADERS

For this project, Ashley Meaders transformed everyday utilitarian hooks into a bright and fun hang-it-all rack. The shape of the wooden plaque adds a bit of that Hollywood Regency flair, and the bright colors would certainly impress Dorothy Draper.

INSTRUCTIONS

1 If you are using a precut wood plaque, you can skip this step. If you are making your own plaque, photocopy the template on page 128 at 300%. Cut out the template and trace around it with a pencil onto a large piece of poster board. Using scissors, cut out the design from the poster board. Lay the stencil on the wood and trace around it with a pencil. Use a jigsaw to cut the wood along the pencil lines.

2 Sand down the front and edges of the wood plaque. Using white primer paint, coat the front and sides of the wood base. Let dry. Paint another coat, if necessary.

3 Using acrylic paints and a small paintbrush, paint each hook a different color. You may need multiple coats of paint to fully cover the hook's surface. Let the hooks dry completely, then apply a coat of sealant to each so the paint does not chip over time.

4 Once the hooks and base are completely dry, play with the layout of the hooks. Once you've decided on your layout, attach each hook with wood screws using an electric drill.

5 When the hooks are all attached, attach small eye hooks and picture wire on the back of the plaque in order to hang it.

FINISHED SIZE:
23 x 21 x 1/2"
(58.5 x 53.5 x 1.3 cm)

MATERIALS
Large poster board

24 x 24 x 1/2" (61 x 61 x 1.3 cm) plywood or a finished wood plaque

White primer paint

Variety of colored acrylic paints for metals

Variety of hooks

Paint sealer

Wood screws

Small eye hooks and picture wire, to hang

TOOLS
Pencil

Scissors

Jigsaw (if cutting out your own wood shape)

Sandpaper

Paintbrushes

Electric Drill

TEMPLATES

PALLADIO TOTE BAG

PAGE 26

*photocopy
at 200%*

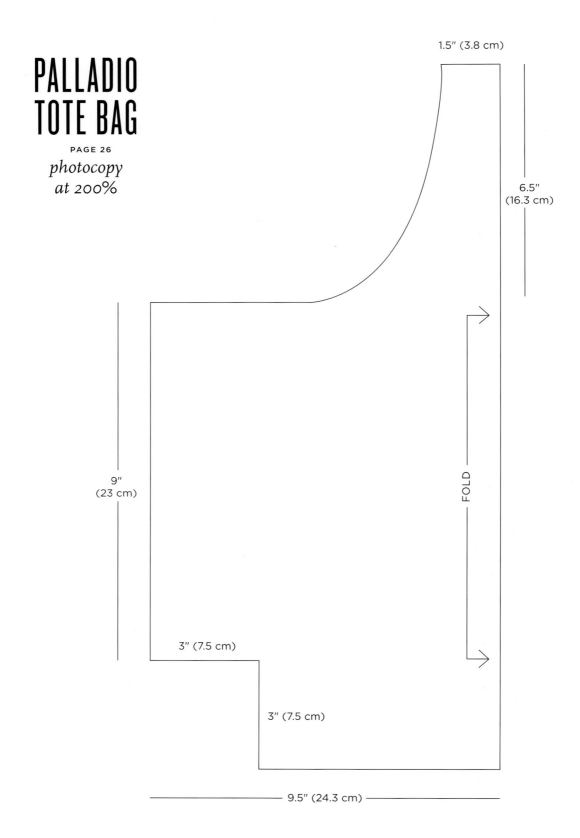

1.5" (3.8 cm)

6.5"
(16.3 cm)

9"
(23 cm)

FOLD

3" (7.5 cm)

3" (7.5 cm)

9.5" (24.3 cm)

CHINOISERIE
PEDESTAL

PAGE 39

photocopy
at 100%

WALLFLOWER HANGINGS

PAGE 53

photocopy at 100%

	1st layer	2nd layer	3rd layer	4th layer
16" (40.5 cm)	6 x petal #1	5 x petal #1	5 x petal #2	5 x petal #4
14" (35.5 cm)	6 x petal #1	5 x petal #1	5 x petal #2	5 x petal #4
12" (30.5 cm)	5 x petal #2	5 x petal #3	5 x petal #5	5 x petal #6

#2

#4

#5

#1

#3

#6

GUSTAVIAN CLOCK

PAGE 64

*photocopy
at 600%*

GOTHIC
HERALDRY
PILLOWCASE

PAGE 77

*photocopy
the letters
at 100%*

*photocopy
the coat of arms
at 150%*

CARDBOARD VICTORIAN CANDLESTICK

PAGE 80

photocopy at 125%

4 3/4" (12 cm) with 3 1/4" (8.5 cm) hole
C

5 3/4" (14.5 cm) with 4 3/4" (12 cm) hole
G

H
6" (15 cm) with 5" (12.5 cm) hole

F
5 1/2" (14 cm) with 4 1/2" (11.5 cm) hole

A
3 3/4" (9.5 cm)

D
5" (12.5 cm) with 3 3/4" (9.5 cm) hole

B
4 1/4" (11 cm) with 2 3/4" (7 cm) hole

E
5 1/4" (13.5 cm) with 4 1/2" (11.5 cm) hole

HOLLYWOOD
HANG-IT-ALL

PAGE 115

*photocopy
at 300%*

ABCDEF GHIJK LMNO PQRST UVWXYZ

BIBLIOGRAPHY

A BRIEF HISTORY OF OBELISKS

Curl, James Stevens. *Egyptomania: The Egyptian Revival: A Recurring Theme in the History of Taste.* Manchester England, United Kingdom: Manchester University Press, 1994.

D'Alton, Martina. *The New York Obelisk or How Cleopatra's Needle Came to New York and What Happened When It Got Here.* New York: Metropolitan Museum of Art/Abrams, 1993.

Habachi, Labib, and Charles Cornell Van Siclen. *The Obelisks of Egypt: Skyscrapers of the Past.* New York: Scribner, 1977.

STUDIOLOS, RENAISSANCE ITALY

Ajmar-Wollheim, Marta, and Flora Dennis. *At Home in Renaissance Italy.* London: V&A Publications, 2006.

Campbell, Stephen J. *The Cabinet of Eros: Renaissance Mythological Painting and the Studiolo of Isabella d'Este.* New Haven: Yale University Press, 2006.

De Dampierre, Florence. *Walls: The Best of Decorative Treatments.* New York: Rizzoli, 2011.

Mauriès, Patrick. *Cabinets of Curiosities.* New York: Thames & Hudson, 2002.

Marek, George R. *The Bed and the Throne: The Life of Isabella d'Este.* New York: Harper & Row, 1976.

PALLADIAN STYLE, RENAISSANCE ITALY

Boucher, Bruce. *Andrea Palladio: The Architect in His Time.* New York: Enfield, 2007.

Rybczynski, Witold. *The Perfect House: A Journey with the Renaissance Master Andrea Palladio.* New York: Scribner, 2003.

VENETIAN MIRRORS, 17TH CENTURY

Melchior-Bonnet, Sabine. *The Mirror: A History.* New York: Routledge, 2001.

Phipps, Paula. *Mirrors: Reflections of Style.* New York: W. W. Norton & Co., 2012.

THE STATE BED, 17TH-CENTURY ENGLAND

Beldegreen, Alecia. *The Bed.* New York: Stewart, Tabori & Chang, 1991.

Snodin, Michael, and John Style. *Design & the Decorative Arts, Britain 1500–1900.* London: V&A Publications, 2001.

Thornton, Peter. *Seventeenth-Century Interior Decoration in England, France, and Holland.* New Haven: Yale University Press, 1978.

CHINOISERIE STYLE, 19TH-CENTURY ENGLAND

Bergreen, Laurence. *Marco Polo: From Venice to Xanadu.* New York: A. A. Knopf, 2007.

Jacobson, Dawn. *Chinoiserie.* London: Phaidon, 1993.

A BRIEF HISTORY OF GREENHOUSES

Whittingham, Sarah. *The Victorian Fern Craze.* Oxford, United Kingdom: Shire Publications, 2009.

Woods, May, and Arete Swartz Warren. *Glass Houses: A History of Greenhouses, Orangeries and Conservatories.* New York: Rizzoli, 1988.

GROTTOES, 18TH-CENTURY EUROPE

Jackson, Hazelle. *Shell Houses and Grottoes.* England: Shire Books, 2001.

Jones, Barbara. *Follies and Grottoes.* London: Constable, 1989.

Miller, Naomi. *Heavenly Caves: Reflections on the Garden Grotto.* New York: G. Braziller, 1982.

ROCOCO STYLE, EARLY 18TH-CENTURY FRANCE

DeJean, Jean E. *The Age of Comfort: When Paris Discovered Casual and the Modern Home Began.* New York: Bloomsbury, 2010.

Scott, Katie. *The Rococo Interior: Decoration and Social Spaces in Early Eighteenth-Century Paris.* New Haven: Yale University Press, 1995.

THE SECRET COMPARTMENTS OF LOUIS XIV

Boyer, Marie France, and Francois Halard. *The Private Realm of Marie Antoinette.* New York: Thames & Hudson, 1996.

Chadenet, Sylvie. *French Furniture from Louis XIII to Art Deco.* Boston: Little, Brown, 2001.

Picon, Guillaume, and Francis Hammond. *Versailles: A Private Invitation.* Paris: Flammarion, 2011.

Weber, Caroline. *Queen of Fashion: What Marie Antoinette Wore to the Revolution.* New York: H. Holt, 2006.

JOSIAH WEDGWOOD, 18TH-CENTURY ENGLAND

Dolan, Brian. *Wedgwood: The First Tycoon.* New York: Viking Press, 2004.

Kelly, Alison. *The Story of Wedgwood.* New York: Viking Press, 1975.

GUSTAVIAN STYLE, 18TH-CENTURY SWEDEN

Baudot, François. *Compendium of Interior Styles.* New York: Assouline, 2005.

Calloway, Stephen. *Royal Style: Five Centuries of Influence and Fashion.* Boston: Little, Brown, 1991.

MacIsaac, Heather Smith, and Lars Bolander. *Lars Bolander's Scandinavian Design.* New York: Vendome Press, 2010.

Sjöberg, Lars, and Ursula Sjöberg. *The Swedish Room.* New York: Frances Lincoln, 1994.

FEDERAL STYLE, 18TH-CENTURY AMERICA

Gura, Judith. *The Abrams Guide to Period Styles for Interiors.* New York: Abrams, 2005.

Howard, Hugh, and Roger Straus. *Thomas Jefferson, Architect: The Built Legacy of Our Third President.* New York: Rizzoli, 2003.

McLaughlin, Jack. *Jefferson and Monticello: The Biography of the Builder.* New York: H. Holt, 1988.

EMPIRE STYLE, EARLY 19TH-CENTURY FRANCE

DeLorme, Eleanor P. *Joséphine: Napoléon's Incomparable Empress.* New York: Abrams, 2002.

Douglas-Hamilton, Jill, Duchess of Hamilton and Brandon. *Napoleon, the Empress, and the Artist: The Story of Napoleon and Josephine's Garden at Malmaison.* London: Simon & Schuster, 2000.

Chevallier, Bernard, and Marc Walter. *Empire Splendor: French Taste in the Age of Napoleon.* New York: Vendome Press, 2008.

Hibbert, Christopher. *Napoleon: His Wives and Women.* New York: W. W. Norton, 2002.

Stuart, Andrea. *The Rose of Martinique: A Life of Napoleon's Josephine.* New York: Grove Press, 2003.

GOTHIC REVIVAL, 18TH-CENTURY ENGLAND

Gore, Alan, Ann Gore, and Peter Aprahamian. *The History of the English Interior.* London: Phaidon Press, 1991.

Gura, Judith. *The Abrams Guide to Period Styles for Interiors.* New York: Abrams, 2005.

Snodin, Michael, and John Style. *Design & the Decorative Arts, Britain 1500–1900.* London: V&A Publications, 2001.

Thornton, Peter. *Authentic Decor: The Domestic Interior, 1620–1920.* New York: Viking Press, 1984.

VICTORIAN ENGLAND, 1837–1901

Beaver, Patrick. *Crystal Palace: A Portrait of Victorian Enterprise.* Chichester, West Sussex, United Kingdom: Phillimore, 1986.

Briggs, Asa. *Victorian Things.* Chicago: University of Chicago Press, 1989.

Calloway, Stephen. *Royal Style: Five Centuries of Influence and Fashion.* Boston: Little, Brown, 1991.

Lasdun, Susan. *Victorians at Home.* New York: Viking, 1981.

Miller, Judith. *Furniture: World Styles from Classical to Contemporary.* New York: DK Publications, 2005.

Mitchell, Sally. *Daily Life in Victorian England.* Westport, CT: Greenwood Press, 1996.

SHAKER DESIGN IN THE UNITED STATES

Burks, Jean. *Shaker Design: Out of This World.* New Haven: Yale University Press, 2005.

Freeman, Michael, and June Sprigg. *Shaker: Life, Work and Art.* London: Cassell, 1989.

Linley, David. *Extraordinary Furniture.* New York: Abrams, 1996.

NATIVE AMERICAN TRADE BLANKETS

Friedman, Barry, James H. Collins, and Gary
Diamond. *Chasing Rainbows: Collecting American
Indian Trade & Camp Blankets*. Boston: Bullfinch
Press, 2002.

Kapoun, Robert W., and Charles J. Lohrmann. *The
Language of the Robe: American Indian Trade
Blankets*. Salt Lake City: Peregrine Smith Books,
1997.

**WILLIAM MORRIS AND THE ARTS
AND CRAFTS MOVEMENT**

Adams, Steven. *The Arts and Crafts Movement*.
London: Grange, 1996.

Gore, Anne. *The History of English Interiors*. London:
Phaidon Press, 1991.

Todd, Pamela. *William Morris and the Arts and Crafts
Home*. San Francisco: Chronicle Books, 2005.

ART NOUVEAU, FRANCE 1890–1914

Duncan, Alastair. *Art Nouveau*. New York: Thames
and Hudson, 1994.

Ferre, Felipe. *Hector Guimard*. New York: Abrams,
1988.

WIENER WERKSTÄTTE, VIENNA 1903–1932

Fahr-Becker, Gabriele. *Wiener Werkstätte: 1903–1932*.
Cologne: Taschen, 2008.

THE BAUHAUS, GERMANY 1919–1933

Weber, Nicholas Fox. *The Woven and Graphic Art
of Anni Albers*. Washington, D.C.: Smithsonian
Institution Press, 1985.

———. *Josef + Anni Albers: Designs for Living*. New
York: Cooper-Hewitt, National Design Museum,
2004.

ART DECO OCEAN LINERS, 1920S AND '30S

Brinnin, John Malcolm, Michel Mohrt, and Guy
Feinstein. *Beau Voyage: Life Aboard the Last Great
Ships*. London: Thames and Hudson, 1982.

Donzel, Catherine. *Luxury Liners: Life on Board*. New
York: Vendome Press, 2006.

Maddocks, Melvin. *The Great Liners*. Alexandria, VA:
Time-Life Books, 1978.

Maxtone-Graham, John. *Normandie: France's
Legendary Art Deco Ocean Liner*. New York: W. W.
Norton & Co., 2007.

Wood, Ghislaine. *Essential Art Deco*. Boston: Bulfinch,
2003.

HOLLYWOOD REGENCY, 1930S AMERICA

Eerdmans, Emily. *Regency Redux: High Style Interiors,
Napoleonic, Classical Moderne, Hollywood Regency,
and Contemporary*. New York: Rizzoli, 2008.

Schifando, Peter, and Jean H. Mathison. *Class Act:
William Haines, Legendary Hollywood Decorator*.
New York: Pointed Leaf Press, 2005.

Varney, Carleton. *In the Pink: Dorothy Draper,
America's Most Fabulous Decorator*. New York:
Pointed Leaf Press, 2006.

DESIGNER BIOS

JONATHAN ANZALONE and **JOSEPH FERRISO** opened Anzfer Farms, a San Francisco–based workshop and showroom, in 2009. They work primarily with reclaimed wood, often finding perfect driftwood pieces on morning walks on the beach. www.anzferfarms.com
INLAID EASEL (page 22)

The **BBBCRAFT** sisters (Anna, Amy, and Sarah Blessing) grew up in Portland, Oregon. They were taught by their mom to love all things art and craft and to create beauty in the everyday. The sisters write about their projects on their shared blog. www.bbbcraft.blogspot.com
SHAKER HANGING LAMP (page 85)

GRACE BONNEY is the founder and editor in chief of Design*Sponge, an online magazine dedicated to creative living. Since it was founded in 2004, Design*Sponge has grown to cover a wide range of topics. In addition to sponsoring an annual scholarship for student designers and artists, Design*Sponge published its first book, *Design*Sponge at Home*, in 2012. The 30-city book tour raised money for local arts charities across the country. www.designsponge.com
MIRROR MOSAIC PLANTER (page 30)

BOOKHOU is a family-run business in Toronto, Canada, cofounded in 2002 by John Booth and Arounna Khounnoraj. They are a multidisciplinary studio and shop, creating everything from tote bags and pillows to mobiles, ceramics, and furniture. They believe in slow design, making each piece one at a time, by hand, using materials that are organic or ecofriendly. www.bookhou.com
PALLADIO TOTE BAG (page 26)

CONFETTISYSTEM is Nicholas Andersen and Julie Ho, a duo working as artists, designers, and stylists who transform everyday objects—such as tissue paper, cardboard, and silk—into shimmering backdrops and sets for the American Ballet Theatre and for brands such as Opening Ceremony, United Bamboo, and J. Crew. www.confettisystem.com
ART DECO MOBILE (OR PIÑATA) (page 110)

ERICA DOMESEK is the founder, creator, and author of P.S.—I made this, a DIY design and style blog. Erica lives in New York City, where she puts to practice her creative motto: "I see it. I like it. I make it." Erica is the author of the book *P.S.—I Made This*, which includes twenty-five fashion-inspired projects. www.psimadethis.com
GROTTO JEWELRY BOX (page 49)

EMERSONMADE is an apparel and accessories company run out of a seaside town in New Hampshire. The company got its start when Emerson Fry made little fabric flower pins for herself and friends and began to get order requests. The business has expanded from those initial flower pins to include clothing and shoes.
www.emersonfry.com
WALLFLOWER HANGINGS (page 53)

RANDI BROOKMAN HARRIS is a freelance prop stylist and creative director who has worked with brands such as Martha Stewart, Kate Spade, and J. Crew. In 2010, Randi coauthored *Paper + Craft: 25 Charming Gifts, Accents & Accessories to Make from Paper*. She currently lives in Brooklyn with her husband, young son, and Boston terrier, Olive, who loves being on photoshoots as both a furry companion and a prop.
www.brookmanharris.com
TASSEL BLANKET (page 34)

MEG MATEO ILASCO is a writer, illustrator, graphic designer, stylist, and the owner of an eponymous line of stationery and home products. She is the author of several books, including *Craft, Inc., Creative, Inc.*, and *Crafting a Meaningful Home*, and her most recent project is a lifestyle magazine called *Anthology*.
www.mateoilasco.com
ARTS AND CRAFTS WOODBLOCK LAMP (page 93)

LADIES & GENTLEMEN STUDIO was founded in 2009 by Jean Lee and Dylan Davis. In their online shop, the duo puts a modern spin on vintage finds or give vintage flair to new designs (such as brightly colored handles added to vintage flatware, brass lamps that are turned into side tables, and area rugs that mimic vintage doilies).
www.ladiesandgentlemenstudio.com
SECRET WINDOW CABINET (page 57)

TIMOTHY LILES graduated from the Rhode Island School of Design with a concentration in furniture design. He worked for more than five years as a footwear designer for Converse and is now the art director for apparel graphics at Hurley, a surf brand based in Orange County, California.
www.timothyliles.com
OBELISK CLOCK (page 19)

ASHLEY MEADERS lives for bright, poppy colors, fringe, and garlands. In addition to being an event designer, Ashley creates props and backdrops for the website Smile Booth.
www.ashleymeaders.com
HOLLYWOOD HANG-IT-ALL (page 115)

CAITLIN MOCIUN graduated from the Rhode Island School of Design with a degree in textiles. Always gravitating toward geometric shapes in strong colors, she started her line with clothing and has since begun to experiment with jewelry designs. In March 2012, she opened her own shop in Williamsburg, Brooklyn, where she sells both textiles and jewelry.
www.mociun.com
NATIVE AMERICAN NAPKIN RINGS (page 89)

SHANNA MURRAY works in illustration, photography, graphic design, printmaking, textiles, styling, and web design, and fills her days with a variety of creative pursuits.
www.shannamurray.com
FEDERAL MIRROR (page 69)

NIGHTWOOD is a small, Brooklyn-based furniture, textile, and home design studio run by Nadia Yaron and Mariah Scruggs. They create new pieces using found furniture and salvaged fabrics and wood.
www.nightwoodny.com
BAUHAUS SHOWER CURTAIN (PAGE 106)

TODD OLDHAM is a fashion designer, television personality, interior designer, product designer, film director, photographer, and writer. He is passionate about design, and he works to inspire. He has authored many books, including *Charley Harper: An Illustrated Life, Handmade Modern,* and a craft book for kids: *Kid Made Modern.*
www.toddoldham.com
CHINOISERIE PEDESTAL (page 39)

KATE PRUITT is an artist and designer living in Oakland, California. Originally an East-Coaster, she moved west to earn a degree in art and art history from Stanford University. She began creating freelance DIY projects in 2008, and is now the senior editor at Design*Sponge, where she has created over 80 original DIY tutorials. She enjoys reading, building things, and spending time with her husband and their inadvertently diabolical cat, JFK.
www.katepruitt.com
GUSTAVIAN CLOCK (page 64)

DIVA PYARI began designing paper goods in 2007 and founded her company, Linea Carta, shortly thereafter. Linea Carta (which is Italian for "paper line" or "paper collection") offers a comprehensive ecofriendly line of stationery. Diva Pyari grew up in the fashion industry in California, and later lived in northern Italy, all along practicing new forms of craft (painting, printing, jewelry making, clothing design, graphic design, and calligraphy).
www.linea-carta.com
GOTHIC HERALDRY PILLOWCASE (page 77)

EDDIE ROSS is a graduate of the Culinary Institute of America and former senior style editor of *Martha Stewart Living*. He burst into the mainstream when, in 2008, he competed on season two of Bravo's *Top Design*. Since the show, Eddie left the publishing world to found a lifestyle company with his partner, Jaithan Kochar. One of Eddie's greatest passions is entertaining, and he loves creating unique table settings—often using pieces from his personal Wedgwood collection.
www.eddieross.com
JASPERWARE HEADBOARD (page 60)

JULIA ROTHMAN has created illustrations and pattern designs for newspapers, magazines, wallpaper, bedding, books, and subway posters. She is part of the award-winning three-person design studio called ALSO and runs the blog Book by Its Cover. She also authored *Farm Anatomy* and *Drawn In* and coauthored *The Exquisite Book*. She lives and works from her studio in Brooklyn, New York.
www.juliarothman.com
EMPIRE-INSPIRED PLATES (page 73)

DAVID STARK is an event and product designer in New York City. He has designed events for the Metropolitan Opera, Saks Fifth Avenue, Louis Vuitton, and Beyoncé, and has designed a line of products for West Elm. Throughout his work, David Stark is known for creatively reusing materials and devising party decor that feels like an art installation.
www.davidstarkdesign.com
CARDBOARD VICTORIAN CANDLESTICK (page 80)

STUDIO CHOO is the work of two best friends, Alethea Harampolis and Jill Rizzo, who share a love for all things natural, wild, and made by hand. In 2009, they started a floral business in San Francisco, creating beautiful arrangements for weddings, local deliveries, and events. The flowers are locally grown whenever possible, and always fresh and seasonal.
www.studiochoo.com
GREENHOUSE COFFEE TABLE (page 43)

THE WILD UNKNOWN is an independent and family-run business based in Brooklyn, New York. Like the designers of the art nouveau movement, artist and musician Kim Krans frequently draws on nature for inspiration for her drawings, prints, and the handcrafted prisms she creates with her mother, Gaynelle Oslund.
www.thewildunknown.com
BRANCH AND CRYSTAL CHANDELIER (page 98)

COLLEEN & ERIC WHITELEY met while studying industrial design at Pratt Institute. Working out of Brooklyn, New York, Colleen and Eric are a design consultancy, an idea factory, and a small-scale manufacturer of furniture and decor.
www.colleenanderic.com
CAST METAL SWITCHPLATE (page 102)

INDEX

RESOURCES

The materials and tools used in the projects in this book are generally available at craft, art supply, and hardware stores nationwide. If you cannot find what you are looking for locally, try these online resources.

GENERAL CRAFTING SUPPLIES

A. C. Moore
www.acmoore.com

Dharma Trading Company
www.dharmatrading.com

Dick Blick Art Materials
www.dickblick.com

Hobby Lobby
www.hobbylobby.com

Michael's
www.michaels.com

Pearl Art and Craft Supply
www.pearlpaint.com

Save-on-Crafts
www.save-on-crafts.com

HARDWARE STORES

Ace Hardware
www.acehardware.com

Home Depot
www.homedepot.com

Lowe's
www.lowes.com

ADDITIONAL SOURCES

Obelisk Clock on page 19
Wall clocks
www.mcmaster.com

Paper arrow stickers
www.mcmaster.com

Mirror Mosaic Planter on page 30
Silver mirror tiles
www.artfire.com

Grotto Jewelry Box on page 49
Small cardboard suitcase
We used a small cardboard suitcase from
Wald Imports (found on Amazon.com)
and removed the handle.

Secret Window Cabinet on page 57
Medicine Cabinet
We used an American Classics 15"
wide Surface-Mount Mirrored Medicine
Cabinet in White #S1620-12-B (available
at Home Depot).

Landscape images
Search the New York Public Library's
digital gallery for interesting landscape
images: digitalgallery.nypl.org.

Gustavian Clock on page 65
Clock hands and clock movement
www.rockler.com

Federal Mirror on page 69
Water-slide decal paper and fixative
www.decalpaper.com

Gothic Heraldry Pillowcase on page 77
Iron-on transfer paper for textiles
Lazertran is our favorite brand of
transfer paper (www.lazertran.com).

**Arts and Crafts Woodblock Lamp
on page 93**
Woodburning toolkit
www.sunsethardware.com

Porcelain keyless lightbulb socket
www.ronshomeandhardware.com

Cast Metal Switchplate on page 103
Bismuth/tin alloy
www.rotometals.com

Easy Mold Silicone Putty
can be found on Amazon.com.

ACKNOWLEDGMENTS

IT TAKES A SMALL ARMY OF PEOPLE TO MAKE A FIRST book, and this one is no exception.

I want to first thank those in the History of Decorative Arts and Design program at Parsons/Cooper-Hewitt for laying the foundation for this project—particularly Donald Albrecht, Laura Auricchio, David Brody, Sarah Lawrence, and Ethan Robey.

Thanks go to the project designers who took time out of their days and away from their own work to contribute to this book. Their creativity is a constant source of inspiration.

Rima Rabbath, Heather Lilleston, and all those at Jivamutki kept me sane during this process, and Lilly Ghahremani, my fantastic lawyer, took care of the nitty-gritty details so I didn't have to.

My friends at the New York Public Library—Lauren Lampasone, Benjamin Vershbow, and Jessica Pigza—answered my spur-of-the-moment pleas to look up names and events. Thanks also go to Micah May, who granted me a sabbatical to do research, and to Joshua Greenberg, David Ferriero, and Ann Thornton, without whose support for the Design by the Book project, I would never have met Grace Bonney.

Thank you to Ellen Silverman and Randi Brookman Harris for creating such amazing photos, and to the many additional hands that helped with the photo shoot, including Lizzy Aubin-Barrett, Lauren O'Neill, Erin Griffin, and Sara Nersesian. Thanks also to Sara Bedford, Alan Hill, Fitzhugh Karol, and Lindsay Caleo for allowing us to shoot the projects in their homes. And thanks to Ben Riordan and Ellen Wulf, who evacuated all the projects from my apartment when Hurricane Irene threatened Brooklyn.

Thanks to Melanie Falick for believing in this book and bringing me into the STC family, and to Liana Allday, without whose consistent encouragement, steadfast editorial support, and thorough editing, I would have never made it through. (Leading an author through her first book is no easy task and this volume would not be the same without her hand-holding.)

Thanks to Julia Rothman, who not only contributed a fantastic project and beautiful illustrations, but also suggested that I write this book over Bloody Marys, oysters, and french fries. Kate Pruitt served as my project adviser, and she helped me keep all the artists on track. Grace Bonney, who leads by example, held my hand every step of the way, from the proposal to the final edit. Without her unwavering support, I would never have had the audacity to attempt this project. The Design*Sponge journey has been an amazing gift, and I can't wait to see where it leads.

Everyone needs a friend you can call at any hour to wallow in the weeds with you, and Rebecca Federman was that and more for me. David Riordan had to live with me through the creation of this book, gamely talked through the minutiae of design history with me, and supported me every step of the way. Thanks to my siblings, Dorie, Shelley, and Matthew, for being my first audience. And finally thank you to my parents, Robert and Susan Azzarito, who raised me in a home filled with books, a love of history, and lots of DIY attitude.

ABOUT THE AUTHOR

AMY AZZARITO IS THE MANAGING EDITOR OF THE online magazine Design*Sponge. Formerly the digital producer in the office of strategic planning at the New York Public Library, she graduated from Parsons/Cooper-Hewitt with a master's degree in the history of decorative arts and design. Her work has appeared in the books *Paris-New* and *West of Center*, where she wrote chapters on the evolution of French cuisine and countercultural architecture. When not researching design history, she practices yoga, skateboards, rides bikes, and tends bees on a Brooklyn rooftop. She lives in Brooklyn, New York.